ELECTRONIC FLASH SIMPLIFIED

A MODERN PHOTOGUIDE

ELECTRONIC FLASH SIMPLIFIED

by

Peter Gowland

AMPHOTO
Garden City, New York 11530

Second Printing, July 1976
Third Printing, August 1977
Fourth Printing, August 1978
Fifth Printing, October 1978
Sixth Printing, May 1979

Library of Congress Catalog Number—75-1970
ISBN—0-8174-0185-7

CONTENTS

1. HOW ELECTRONIC FLASH WORKS 7

2. TIPS ON BUYING A SPEEDLIGHT UNIT 19

3. SYNCHRONIZATION 27

4. BASIC LIGHTING 35

5. BOUNCE LIGHT 45

6. SYNC-SUN 53

7. SYNC-SHADE 59

8. MULTIPLE ELECTRONIC FLASH 65

9. ACTION WITH ELECTRONIC FLASH 75

10. BLACK-AND-WHITE TECHNIQUE 81

11. COLOR CHARACTERISTICS 87

12. GLOSSARY OF TERMS 94

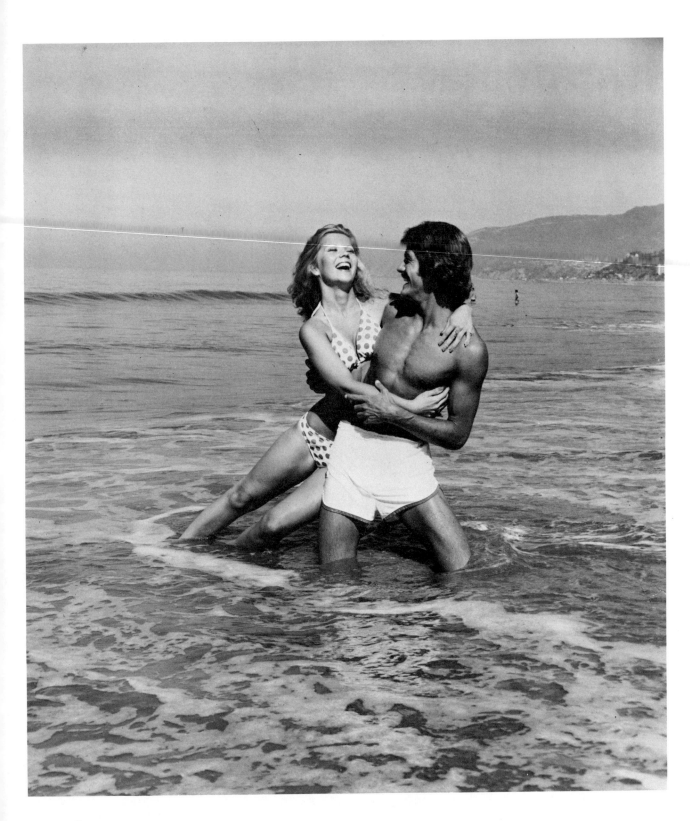

1

HOW ELECTRONIC FLASH WORKS

Electronic flash, like television, has been improved and popularized since World War II. Since the war years, I have used 40 different speedlight units in producing something over 100,000 negatives and color transparencies. In a word, I am sold on electronic flash as a top-quality photographic tool.

ADVANTAGES OF ELECTRONIC FLASH

Any speedlight unit made and guaranteed by a reliable manufacturer has many advantages over flash lamps. Among them:
• It will minimize your cost-per-flash because it can be fired thousands of times before replacement parts are needed.
• It will "freeze" subject movement completely at speeds (depending upon the unit) of from 1/250 sec. to 1/50,000 sec.
• At the same time the powerful flick of flash freezes subject movement, it eliminates camera movement—the most common fault of pictures made with hand-held cameras.
• With a speedlight unit you have no problem of carrying, changing, and disposing of flash lamps.
• The light delivered by an electronic flash unit closely approximates the color quality of daylight. In most cases you can use daylight color film, indoors or outdoors, without filters.
• Electronic flash is a crisp, penetrating form of light, which produces amazing detail in shadow areas.
• Electronic flash is considerate of your subjects. Squints and nervous tension are greatly reduced by the absence of hot lights and the short flash duration.

Gowland uses a moderately priced unit which contains a built-in rechargeable nickel-cadmium battery. An automatic computer-flash operation gives the correct exposure automatically.

THE PRINCIPLE OF ELECTRONIC FLASH

From the photographer's point of view (as distinguished from that of a technician or electronics engineer), there are only a few things you actually need to know about speedlight. Generally speaking, two things are required of any size or type of unit you buy:
1. A condenser, or capacitor, where high-voltage energy is stored.
2. A gas-filled tube in which the stored energy is suddenly released.
Imagine, if you will, a bucket being filled with water from a garden hose. When the bucket is full, you suddenly dump out the water. With a speedlight unit, the capacitor serves as a bucket. It takes a few seconds to fill the capacitor with electricity. When full, the energy stored in the capacitor is discharged at a speed of at least 1/250 sec. (and usually much faster), creating a bright spark inside a xenon-filled glass tube.
A length of wire (electrode) at each end of the tube is connected directly to the capacitor. This capacitor stores the energy that will be released through the flashtube and cause a brilliant flash of light.

Left, one flash head on camera is fine for candid mood shots. Right, two flash heads were used to obtain texture and wire-sharp detail.

To trigger the flash, a momentary high-voltage pulse is applied to the trigger terminal on the flashtube and to one electrode terminal. A wire leading from the trigger terminal applies the pulse to the wall of the glass tube. This high-voltage pulse ionizes the gas inside the tube, making it conductive, and permits the capacitor to discharge its stored energy into the flashtube.

THE SOURCE OF THE ENERGY

Electronic flash capacitors in the popular-size units are charged with 300–2,000 volts of direct current. There are several ways in which this can be accomplished. A multi-vibrator can be used with either wet-cell or nickel-cadmium batteries. Or a transformer can be used to convert 115 or 120 volts of house current to the higher voltage required. Some units work on the "lower high voltage" by using a 510-volt B battery and operating the condenser on the same voltage. This eliminates extra parts and waste of power.

Multi-vibrator circuits are used on low-voltage-battery portable units. The cost-per-flash is low due to the ease with which the unit can be recharged overnight by plugging it into a regular AC house outlet.

Multi-vibrator circuits themselves require energy, but with the efficient solid-state circuits available today, this energy loss is minimal.

WATT-SECONDS

Most electronic flash units are rated in terms of watt-second input. This refers to the energy-storing capacity of a condenser and the voltage to which it is charged. Or to put it technically, watt-seconds represent the product of condenser capacity times the voltage squared, divided by two.

The important thing to remember is that watt-second input *is not* a measurement of the unit's *output*. The amount of light actually produced by a flashtube is rated in Effective Candlepower Seconds (ECPS), Beam Candlepower Seconds (BCPS), or Lumen Seconds.

Two units of identical make and size often vary in the amount of energy they are able to store. Since this difference can affect your exposure by as much as a half stop in either direction, it's always a good idea to double-check the "guide numbers" for your particular unit. We'll discuss the "how-to" of arriving at a personal set of guide numbers in a moment.

Professional stunt man Paul Stater takes a header at a preselected spot. Sync-sun flash illuminates the near shadow areas that would otherwise have been rendered pitch black.

Bobby Diamond and Mary Lee Gowland posed for these semi-candids. Speedlight lets you reshoot a scene inexpensively and is far easier on a subject's eyes than regular flash or flood.

WHY ACCURATE GUIDE NUMBERS ARE ESSENTIAL

Correct exposure with electronic flash (as with regular flash lamps) depends upon three factors:

1. The power output of your light source.
2. The distance between your light source and subject.
3. The "speed index" of each type of film you use.

The power of your light source is the only constant factor you have to work with. The lens opening required for a correct exposure changes each time the light-to-subject distance is changed (except in the new automatic units) and each time you switch to a film with a different speed index.

These three factors have been interpreted in the form of a "guide number."

SAMPLE GUIDE-NUMBER CHART

When you purchase a speedlight unit, guide numbers for use with various films will probably come with it. Assuming the watt-second rating on your particular unit to be correct, here is a chart of the *approximate* guide numbers you can expect.

Most small, portable flash units have a power input of 30–50 watt-seconds. Medium to large portable units provide 100–200 watt-second input. The professional, non-portable studio units range from 125 up to 30,000 or 40,000 watt-seconds.

FILM-SPEED INDEXES

Nowadays you can buy film with daylight exposure indexes ranging from ASA 25–1600 or more. For the sake of simplicity, I suggest that you limit yourself to one or two color films and a couple of black-and-white emulsions.

Exposure-index information for a particular film can usually be found on an instruction slip enclosed in the film carton. For daylight Kodachrome 25, the exposure index is ASA 25. For Ektachrome-X and GAF 64 it is ASA 64, for Kodacolor II it is 80. In black-and-white emulsions, I suggest you choose a slow film of about ASA 50, and a fast film with a daylight index of about ASA 400. If you want to add a third black-and-white emulsion, a medium-speed film with an index of ASA 100 may come in handy.

You'll find that most manufacturers of electronic flash units provide reliable guide-number ratings on Kodachrome 25 film. This is because the processing of Kodachrome 25 is standardized and cannot be manipulated. Should the emulsion speed of daylight Kodachrome 25 ever be changed, you will, of course, need a new guide number for your unit.

B. C. P. S. (Beam Candle Power Seconds)	GUIDE NUMBER	A.S.A. EXPOSURE INDEX
100	12.5	20
150	15	25
200	20	30
250		32
300	25	35
350	30	40
400	35	
500	40	45
600		50
700	50	
800		60
900	60	64
1000		70
1200	70	
	80	80
1500	90	
1750		90
2000	100	
2500	120	100
3000	150	110
3500	175	120
4000		125
4500	200	130
5000		140
6000	250	150
7000	300	160
8000		170
9000	350	180
10,000		190
11,000	400	200
12,000		
13,000	450	
14,000	500	
15,000		
20,000	600	250
	700	
30,000	800	300
	900	
40,000	1000	400
50,000	1200	
60,000		500
70,000	1500	
80,000	1750	600
90,000	2000	
100,000		700
125,000	2500	800
150,000	3000	900
200,000	3500	1000
250,000	4000	1100
300,000		1200
	4500	1250

BLACK-AND-WHITE GUIDE NUMBERS

Where black-and-white films (and other types of color films) are concerned, however, some manufacturers seem to be inclined to overrate the power of their flash units. In this case they are taking advantage of the fact that the useful speed latitudes of these films are to some extent elastic. In other words, their useful speeds can be increased by manipulating the developing procedures.

Speedlight is excellent for portraiture. Both the angle of light and number of flash heads used affect the final result. Left, William F. Overpeck, architect. Below, Suzanne Copeland.

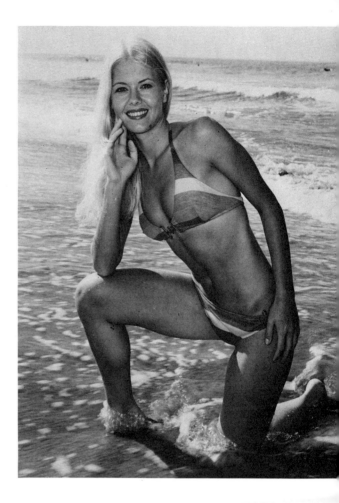

Just because the model is wet doesn't mean she has to be outdoors. Right, Misty Rowe poses in the surf, with sun at her back and strobe fill. Below, Suzanne Copeland, her body oiled and then wet, poses in the studio with the same lighting technique—strobe backlight and front main light.

Candid family album shots are easy to take with single flash.

HOW TO OBTAIN YOUR OWN GUIDE NUMBERS

If you want to check the efficiency of your unit or establish reliable guide numbers for films of your choice, here is an easy way to go about it:

1. Measure off a distance of exactly ten feet between your flash unit and subject.

2. Load your camera with the type of film you want to test. Then take a series of exposures—one for each diaphragm opening your lens provides. It will simplify matters if you record the *f*/stop being used on a card and include the card in each picture.

3. After the exposed film has been developed, decide which frame is correctly exposed.

4. Multiply the correct *f*/stop opening by the distance of ten feet, and you have an accurate guide number for the type of film you tested. If the best exposure was made at *f*/2, for example, your guide number is 20. If an *f*/4 opening produced the best picture, your guide number is 40.

Repeat this procedure for each type of film you expect to use.

TWO WAYS TO USE GUIDE NUMBERS

Auto-flash units eliminate the need for guide numbers in *most* situations, but beyond their "auto" range, these apply.

1. A guide number divided by the flash-to-subject distance will tell you which *f*/stop to use.

2. If you've already decided which *f*/stop you want to use, dividing the guide number by the *f*/stop will tell you what the flash-to-subject distance should be.

Supposing, for example, you have a unit that gives you a guide number of 40 when used with a film having an exposure index of 25. If you want to photograph a subject at a flash-to-subject distance of 5 feet, dividing your guide number (40) by the distance (5 feet) will give you 8; that is, a lens opening of *f*/8.

Now let's turn it around. Supposing you've already decided you want to use a lens opening of *f*/8. How far should you place the flash unit from your subject? Dividing the guide number (40) by the lens stop you decided upon (*f*/8) gives you 5; i.e., 5 feet.

14

Children respond well to working with adults. Here, model Merci Rooney jokes with Carolyn Crosslin to achieve a mother-daughter relationship.

Pets often grow restless under floodlights. With speedlight, they are recorded on film, sharp and clear, before they know what's happening.

WATCH THE FLASH-TO-SUBJECT DISTANCE!

Notice that we always speak of flash-to-subject distance, never of camera-to-subject distances. With all types of artificial illumination (the same as with sunlight) the only thing that counts is the amount of light reaching the subject. The distance between the camera and the subject *has no bearing upon the exposure problem.* The camera could be on the moon as far as the exposure problem is concerned.

CHARTING YOUR GUIDE NUMBERS

Once you have arrived at the correct guide numbers to be used with various types of film, I suggest that you make up a reference chart that can be permanently attached to your flash reflector. Here, for example, is the chart I use with a 100 watt-second unit. It tells at a glance which f/stop to use at four flash-to-subject distances with five different films.

Distance in Feet	Exposure Indexes of Daylight Films				
	32	50	100	200	400
5	f/11	f/16	f/22	f/32	—
7	f/8	f/11	f/16	f/22	f/32
10	f/5.6	f/8	f/11	f/16	f/22
14	f/4	f/5.6	f/8	f/11	f/16
100 Watt-Second Guide Number	40	56	80	110	220

When you use a recommended guide number, remember that it is meant to provide a correct exposure in an average-size, light-colored room. When shooting in large halls, in rooms with dark walls and furnishings, or at night, it may be necessary to allow up to two full f/stops of additional exposure.

Anne Gowland was photographed with single flash on camera.

2

TIPS ON BUYING
A SPEEDLIGHT UNIT

In Chapter 1 we discussed characteristics common to all speedlight units. When the time comes to actually choose a unit, however, you will face a wide assortment of styles, refinements, and prices.

Before you visit your photo dealer, I suggest that you study a comparison chart of the various portable units on the market. You'll find these charts published periodically in the photographic magazines, like *Modern Photography, Popular Photography,* and others. Check each magazine's annual index of the articles it has featured during the year.

The comparison charts are loaded with vital information. Notice how the Kodachrome guide numbers, the watt-second input, the power supply, and the weight of the various units compare within each general price bracket. Note, too, the versatility and refinements the various units have to offer. When you have narrowed your possible choices down to two or three units, visit a photo dealer who will take a genuine interest in your problems—and get his recommendations.

Above everything else, you want a unit that suits *your* picture-taking needs. While you are studying comparison charts, keep these questions in mind.

How often will I use the unit? If you plan to take only a half-dozen pictures a month, it might be cheaper to stick to ordinary flash cubes. It takes a lot of cubes at 10¢ to 15¢ each to amount to $60, which is the initial cost of a moderately priced amateur unit. It's *after* you own a unit that you save money on the cost-per-shot. About 2¢ per flash is roughly par for the course. When you shoot 25, 50, or 100 pictures per sitting, speedlight becomes a real money-saver.

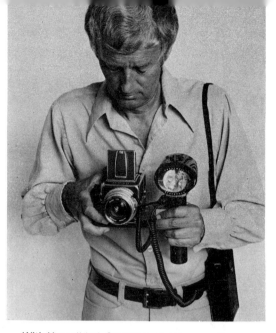

With Hasselblad, Gowland uses Honeywell Auto/Strobonar 880. The strobe operates on 510-volt dry-cell battery or on 110-volt AC unit that hangs from his shoulder. The strobe can be used with flashtube plugged into top. It sets its own exposure automatically—as short as 1/50,000 sec.

How much power do I really need? In general, the amount of power you will need depends upon where your picture-taking needs fit into the following categories:

a. If your picture taking will be limited to medium-distance and close-up shots with a miniature camera, a small, portable, 50 watt-second unit will probably be adequate.

b. If you use a medium-size camera (2¼" × 2¼" negative) and want medium distance with your flash, a 100 watt-second unit is recommended.

c. If your camera takes a 4" × 5" negative (or larger) or if you expect to shoot at long flash-to-subject distances, a 200 watt-second portable unit is probably your best bet.

One of the main differences in portable units lies in the kind of batteries they use.

Low-Voltage-Cell Units. For occasional, intermittent shooting—say a half-dozen or so flash shots a week—a unit powered with photoflash D, C, or AA ("penlight") batteries is ideal. An inexpensive unit will give you up to 100 flashes on each set of batter-

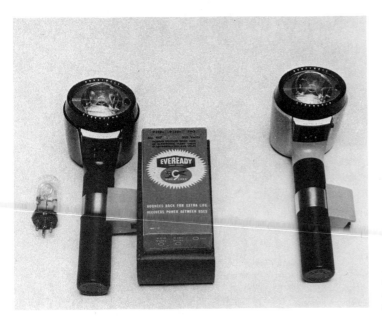

Two popular portable flash units from Honeywell. The Auto/Strobonar 880 uses either AC or a 510-volt battery and has two flashcubes. The Auto/Strobonar 770 uses AC or built-in rechargeable batteries.

ies. One of the new automatic units ($50–$70) will yield up to 200 flashes on a set of batteries.

Nickel-Cadmium Batteries. Nickel-cadmium batteries offer several advantages over other power sources. For one thing, they provide a constant power output over a long period of life. Moreover, a nickel-cadmium battery is not harmed by overcharging, *providing* the charge rate is not excessive. Most manufacturers will not supply a charger that can harm the battery, even on overcharging.

Portable 510-Volt, Dry-Cell Units. A unit of this type weighs about 3 pounds and will yield up to 1,000 flashes with intermittent use. Cycling (recharging) time is rapid—3 to 5 seconds—even during sustained, continuous picture taking. The cost of a nonrechargeable 510-volt battery is about $27

list. A speedlight unit without battery costs about $125.

Portable Rechargeable Cells. There are two types of units on the market that utilize rechargeable dry-cell batteries: One uses the nickel-cadmium cells (mentioned above), which can be recharged a great number of times. The second type of unit employs a transistor and a special cell.

Transistor units of 40–50 watt-second capacity range upward from about $40.

Studio AC Units. For the photographer who has need of multiple lights for indoor, studio-type pictures, an AC unit gives the most light for the least cost. By using regular 115-volt current, batteries are eliminated. Built-in modeling lights illuminate a subject exactly as it will be recorded when the flash is triggered. An AC unit lists for anywhere from $125–$8,000.

20

REFLECTOR ANGLE

Most speedlight units are designed to distribute light evenly over the area covered by a normal focal-length lens; i.e., a 75mm lens on a 2¼" × 2¼" negative-size camera or a 50mm lens on a 35mm camera.

An even distribution of light over the *entire* picture area is essential. If you expect to use wide-angle lenses occasionally (a 60mm lens on a 2¼" × 2¼" camera or a 35mm lens on a 35mm camera, for example), make certain that the speedlight unit of your choice is capable of distributing light evenly over the entire area covered by your wide-angle lens.

Here is a simple way to check the reflector's angle of light coverage:

1. Photograph a blank wall, using a lens with the maximum angle of view you want the light to cover.

2. Develop your film (negative or transparency), and hold it to the light.

If the flash has been evenly distributed, there will be no gradations of color or density in the test shot.

If the light is concentrated in the center of the picture area and falls off towards the edges, you are getting a "hot spot." Chances are the flash is being confined to a relatively narrow beam, either through design deficiencies or as an intentional device for building up the Kodachrome guide-number rating for the unit.

If you notice a "patterned" effect of hot spots and shadow areas, the reflector is again at fault. And although you might use this unit for months without noticing the pattern in your pictures, there is always the chance of its showing up under certain subject and background conditions.

RECHARGING TIME

In buying a speedlight unit, be sure to take note of its recharging time. For correctly exposed pictures, you have to wait until the unit has stored up a full charge of energy. By studying the ready light, you can tell how long you will have to wait between exposures.

Combination windowlight and electronic flash. The model is Jeanne Rainier.

Combination sun backlight and electronic flash.

Single flash to right of camera.

The ready light, however, indicates that the unit is properly storing energy for the next flash; it *does not mean* that maximum light output is available the instant the ready light glows. As a rough rule of thumb, you should allow an interval between flashes of twice the time it takes the ready light to glow. This practice will insure full light output and consistent results, especially with color films. In other words, if the ready light comes on in three seconds, wait an additional three seconds before shooting.

In actual use, make it a habit to conserve battery strength by switching to "Off" if a long interval is to take place between pictures. When a battery has had heavy use over a short period of time, or when it begins to approach its maximum charge expenditure, the length of time it will take the ready light to glow after each flash discharge will be lengthened.

PRICE AND WEIGHT

An electronic flash unit is a precision instrument. I strongly advise you to buy only a known brand, guaranteed by a reputable manufacturer. An "off-brand" is not a bargain at any price.

All of the units made by reliable manufacturers are competitively priced.

The higher the guide number, the more expensive the unit.

The more power you buy, the larger the component parts will be. To double the power, you will often have to more than double the condenser and battery weight.

In choosing a unit (as far as weight and size are concerned), I suggest that you think in terms of the kind of cameras you will use. If you plan to use a small camera with a fast lens, a light-weight unit will probably take care of your lighting problems. The larger the camera you use, the more you will have to stop down the lens to hold various objects in focus, and the more power you will need in order to illuminate your subjects.

Roughly speaking, you pay about $1.75 per watt-second of portable unit power. The price per watt-second lowers, however, when you move into the heavy, nonportable professional units. An 800 watt-second AC unit will probably cost under $600 because there are no batteries to buy.

A WORD OF CAUTION

If you are not familiar with electrical equipment, *don't* attempt to take a speed-light unit apart. Since the capacitors retain a charge even when the power is disconnected, bleeder resistors should always be provided. As an added safety measure, the unit should be flashed, if possible, after the switch is turned off. This will remove the bulk of the residual charge.

Normally, there is not enough energy stored in a capacitor after the power has been disconnected to do much physical damage. But the unexpected shock it can deliver—when tampered with—can be frightening, and the secondary results can be serious.

Key light, fill light, and background light.

One light on each side of subject, directed on the background.

For black backgrounds, as in this picture of Anne Gertcheck, more backlight is necessary to give a dramatic effect. The main light came from the left, leaving part of the face in shadow.

3

SYNCHRONIZATION

WHAT "M" AND "X" MEAN

Many cameras nowadays come with shutter settings marked "M" or "X." Some of the better cameras feature both settings. These are sync settings, intended for use with ordinary flash lamps or electronic flash.

The main difference between the flash of light produced by a regular flash lamp and that produced by an electronic flash unit is the length of time it takes the light to reach its peak of brilliancy after the electrical energy has been released.

With all regular flash lamps there is a certain delay or lag between the instant you press the button and the resulting burst of light. "M" synchronization is for all flash lamps that require up to 1/50 sec. to reach their peak of light output. Included in this group are Nos. 5, 25, and M5 flash lamps. Their effective picture-taking light lasts about 1/60 sec.

The flash from an electronic flash peaks instantly. There is no delay between the time you press the button and the maximum brilliancy of the light; in fact, the light peaks so fast that the shutter has to be opened *before* the electrical energy is released. "X" synchronization takes care of this mechanical problem.

HOW TO CHECK YOUR SYNCHRONIZATION

Supposing you take speedlight pictures with your camera set for "M" or ordinary flash-lamp synchronization. What then?

No pictures. Your light will have flicked on and off *before* your camera shutter opened.

For Karen Maybay, the lighting was directly from the front, which is one of the most flattering placements, since it eliminates harsh shadows.

Most cameras that provide "X" synchronization are clearly marked. If you are not sure about your camera, here is a simple way to find out whether or not it can be used, as is, for speedlight:

Connect your camera and electronic flash unit with the proper cord. Point your flash reflector at a light-colored wall. Set your camera lens at its widest opening. Open the camera back and watch for light coming through the lens when you trip the shutter at various speeds. When you see a perfect circle of light, your synchronization is on the nose.

The picture at the top of page 28 will help clarify this setup. Note the perfect circle made by the open shutter blades. If you see a star-shaped image—or any shape other than circular—you have imperfect synchronization.

CAN ANY SHUTTER BE SYNCHRONIZED?

Generally speaking, yes. Indoors, the shutter speed itself has very little to do with

Shutter blades in perfect sync.

the picture. The light itself records the image from about 1/250–1/20,000 sec., depending upon the type of unit you are using. In that sliver of a second your images have been frozen crisp and sharp, and if there is no other illumination in the room to provide a "ghost" image, your shutter might just as well have been on "B" (time exposure).

With a between-the-lens shutter, any convenient speed can be used because the shutter is invariably open much longer than the duration of the flash. This being the case, it is usually a simple matter for a camera repairman to synchronize your shutter for speedlight.

For a big focal-plane camera like a Graflex, an "open-flash" synchronization is needed so that when the mirror moves up, the flash unit will be triggered. In this case, open flash of about 1/5 sec. can be used indoors or in situations where no light other than the flash will strike the film. Small focal-plane cameras are limited as explained on page 33.

Left, sync-sun shot with flash on the camera. Right, speedlight flash was used to brighten the shadow area of this photograph, taken in Australia. Jennifer Jones is the lovely model.

The key to sync-sun picture taking is to have the subjects turn away from the sun to avoid squinting. Use flash to fill in the shadows. Lovely Kathy McCullen poses here.

When photographing children with adults, outdoor settings are sometimes more natural, and the children are easier to handle. Use of the Larson soft-shoulder, with flash bounced into the reflector, gives a warm and intimate feeling.

USING ELECTRONIC FLASH OUTDOORS

We'll have more to say on this subject when we talk about sync-sun and sync-shade in Chapters 6 and 7. Meanwhile, here are several thoughts to keep in mind if you plan to use electronic flash outdoors.

Where the flash itself provides *all the light* for a picture, shutter speed is of no importance in stopping action. In a dark room, for example, you could take a speed-light picture on "B" (time exposure) and still have the action-stopping equivalent of a shutter speed of 1/250–1/20,000 sec.— whatever the duration of the flash happened to be.

Outdoors, you have existing light to consider. Here you *must* use a shutter speed fast enough to stop the subject's movement. Otherwise, a double image may result. One image will have been recorded by the flash; a second image will have been registered by the daylight.

Model photographed with single flash held off camera.

LIMITATIONS OF FOCAL-PLANE SHUTTERS

With a between-the-lens shutter you will probably have no difficulty in choosing a shutter speed fast enough to stop a subject's movement for sync-sun pictures. With a focal-plane shutter, it may not be so easy. Most small cameras have focal-plane shutters that are fully open only at speeds up to approximately 1/60 sec. At higher speeds (1/100 sec., 1/500 sec., etc.), the traveling slits in the shutter curtain are so narrow that only a small portion of the film will be exposed in the fraction of a second the flash exists. Thus, the curtain will block off most of the effectiveness of your flash illumination.

PRESS-TYPE FOCAL-PLANE CAMERAS

Press-type and other large focal-plane cameras (accepting 4″ × 5″ negatives as a rule) present a special problem for flash work. While they can be used for open-flash shots indoors when there is little or no existing illumination on the subject, their outdoor use is limited to nonflash pictures. They can't be reliably synchronized for daylight flash use.

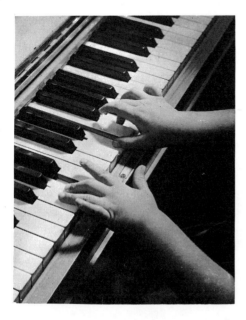

I like to record the changing moods and everyday activities of children. Single flash—direct or bounced—does the trick easily, quickly, and at minimum cost.

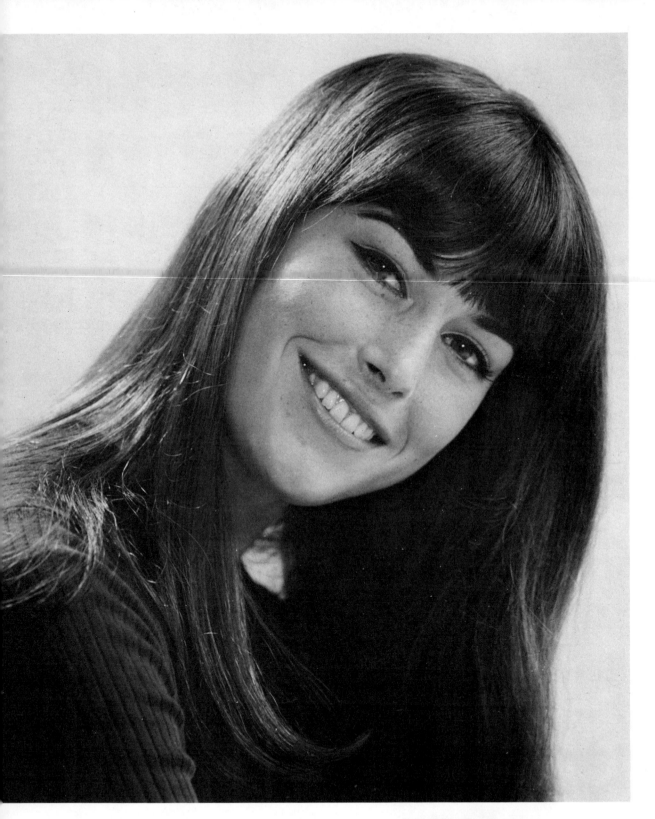

Pretty Susan Beck is photographed with the Gowlandflex camera and Honeywell Auto/Strobonar 880 plus an overhead light.

4

BASIC LIGHTING

Light is an interpretative tool in the hands of a photographer. He can make it harsh or soft, revealing or concealing, flattering or libelous. The more he knows about the versatility of light, the easier it is to cope with any picture-taking situation he encounters.

ON-THE-CAMERA FLASH

Many photographers attach the flash head of their speedlight unit to the camera and simply leave it there. This method offers both limitations—and advantages. Personally, I shoot many more pictures with the flash on the camera today than I did as a beginner. Here are some of the reasons why:

Even Illumination. With a single flash head you have to be careful to aim the reflector in the exact direction of your camera lens. If you don't, you are likely to have a hot spot to one side of your main subject area. When you try to hold the flash head in one hand and the camera in the other, it's hard to keep both aligned and, at the same time, keep an eye on your subject. Multiply your subjects—at a party, for instance—and the procedure becomes too tricky to suit me. I just leave the flash on the camera and fire away—assured of good alignment and even lighting.

Flattering Light. You've heard it said: "This candid nightclub shot is the most flattering picture I have ever had taken, and it cost only $3.00. My $50 portrait isn't a bit better."

Why is the nightclub candid so pleasing? Because it was snapped with so-called flat lighting. While the portrait photographer tried for modeling, texture, and character, the nightclub artist wanted only smooth skin. A pearly smile was permissible, but he

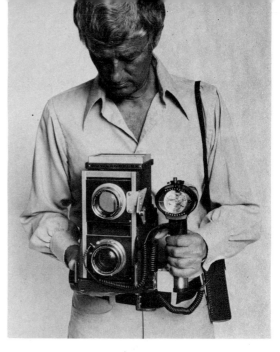

When shooting 4" x 5" color film with the Gowlandflex, Gowland uses the Honeywell Auto/Strobonar 880 with a 510-volt battery. Guide number with ASA 50 Ektachrome is 110. The Gowlandflex works like a large Rollei and takes 180mm, 210mm, 240mm, or 360mm lenses. You can also use size 120, 70mm, 90mm, or 5" x 7" film. Gowland is the designer and manufacturer of the Gowlandflex. Free information is available by writing Peter Gowland, 609 Hightree Road, Santa Monica, Ca. 90402.

had no intention of picking up the 2 A.M. crow's feet at the corners of the eyes.

When in doubt or under duress from family or friends, borrow the nightclub photographer's sure-fire recipe. Leave the light on the camera!

Candidness. Half the fun of owning a speedlight is the chance it gives you to capture the unexpected—the truly candid shot. A strange dog and cat in sudden juxtaposition . . . A two-year-old and a jar of chocolate syrup . . . When spontaneity sparks the action and fast camera handling is a must, the fewer items of equipment you have to worry about, the better. Rather than three pieces of equipment to handle (battery case, reflector, and camera), I use the most compact, self-contained unit I can get. One that has the batteries contained in the flash head, which, in turn, attaches to the camera, suits me fine.

Single flash bounced off a reflector.

For a glamorous portrait technique, Hollywood studio photographers place the model on the floor so that her hair frames her face. Here, model Diane Zapanta is in a relaxed position and can produce a variety of expressions more easily.

36

Sync-Sun. In using electronic flash with sunlight (See Chapter 6), the function of the speedlight is usually that of a fill-in light. The sun, in other words, is the main light source. The flash simply illuminates the deep shadow areas. Since you generally want the fill light as close to the camera as possible, I have found it easiest to leave the flash right on the camera.

ABOVE-THE-LENS FLASH

Visually, some of your best shots will be made with the flash reflector off the camera. Whether to left or right of the camera, it will tend to throw the shadows down behind the subject as long as it is held *above* the camera.

This is one way of minimizing the distracting background shadows that occur when a subject standing close to a wall is photographed with the flash at lens level. Moreover, a higher-than-camera flash makes the viewer less conscious of the flash illumination because it more closely approximates the normal position of the sun or ceiling lights.

Some photographers use a bracket to raise the flash head well above the lens level. Others handhold the flash head. My preference leans toward handholding because it is more flexible—especially when you want to turn the camera sideways in order to shift from a horizontal to a vertical format.

REFLECTING SURFACES

In using a single speedlight, don't overlook the possibilities of putting reflecting surfaces to work. A side wall, sheet, or foil-covered reflector can often do the fill-in work of a second light. Then, too, there are infinite possibilities in directing the flash so it caroms off several reflecting surfaces before illuminating the subject. The subject of bounce-light technique will be covered more fully in Chapter 5.

LIGHTS FROM AN ANGLE

Light that is far enough off the camera to illuminate the subject from an angle produces modeling or roundness. Artistically, this type of light creates the illusion of a third dimension—depth—and is, therefore, more pleasing to the eye than the two-dimensional effect you get with direct front light.

Light from an angle can also be used to interpret the *texture* of a subject. The ripples in a sand dune are a perfect example of this. When viewed in direct overhead or front light, the ripples are hard to see and uninteresting to the eye. When the angle of the sun crosslights the ripples in the early morning or late afternoon, their texture and pattern are dramatized by highlights and shadows.

Indoors, two things are of prime importance in determining the modeling and texture effects you will get: first, the surface of the subject itself; second, the way you light that subject.

To illustrate these points, let's imagine that you are about to photograph an egg and an orange together.

If you use direct front lighting, your picture will record a two-dimensional concept of height and width but convey very little feeling of roundness (depth) or texture.

If you light them from the side (as though your flash were a late afternoon sun), both objects will acquire the illusion of depth. Only the orange, however, will reveal texture. The egg, having a far smoother surface, will be almost as textureless as a billiard ball.

Let's substitute a baby for the egg and an elderly person for the orange. In front light, most of the lines and wrinkles in the face of the elderly person will be minimized by the even balance of the light. Lighted from the side, however, every ridge will be highlighted and every crease will become a shady canyon. The baby, on the other hand, can stand sidelighting. Like the egg, he's smooth surfaced to begin with.

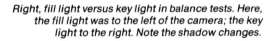

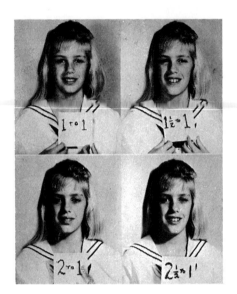

Right, fill light versus key light in balance tests. Here, the fill light was to the left of the camera; the key light to the right. Note the shadow changes.

Practice moving one light (preferably a flood) around a subject, watching the effect that the angle and height of the light have upon modeling and texture. Note, too, where the shadows are cast, and how each light-and-shadow combination produces a different interpretation of the subject.

ADDING A SECOND LIGHT

This is where compromise and lighting balance enter. The degree of texture and modeling you get in a picture depends upon the angle and *strength* of your key or main light. The stronger the key light, the deeper the shadows it casts. When you use a reflector or a second light in such a way as to balance the key light, details become visible in the shadow areas. The stronger the fill light, the more translucent the key light's shadows become. With floodlights, or sunlight and a reflector, you can study the changes that take place when you alter the balance between your main and fill lights. With speedlights, achieving the balance you want has to be based upon experience unless you have a pilot (modeling light) on each of your flash heads.

To start with, I suggest you work towards a light-balance ratio of 1:1. This is accomplished by placing one light on each side of your camera so that each light is at the same height, distance, and angle from your subject. Make several exposures by varying the positions of the light, but keeping them equal in every respect. Then, gradually start moving the fill light further away from the subject without changing the position of the key light. Work towards a ratio between the key and fill light of 1:1½, then 1:2, 1:2½, and so on. Don't be hesitant to spend some time and film on these experiments. You'll be repaid many times over in the future by knowing what to expect from your key and fill lights.

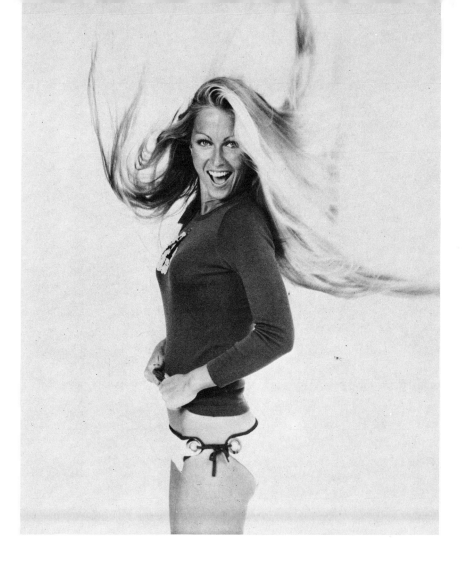

To get this action effect, Kathy Glade leaned over and then flung her head up so that her hair flew up and around. Many exposures are necessary to catch the one with the very best composition.

MORE ABOUT DOUBLE LIGHTS

Fill Light on Background. The obvious placement, when using two lights, is to direct both of them on the subject (as we've just discussed) from a front or three-quarter front position so that one light serves as the key and the other as the fill. My personal preference for a two-light setup, however, is to direct the fill light on the background.

For a setup of this type, the key light is positioned above the camera position (and sometimes a few degrees to the right or left of the lens), and it is inclined slightly downward to create a darker area around the edges of the face and figure where the light glances off these curved surfaces. The fill light is directed upon the background itself, which is preferably of a light or neutral tone. In this position, the fill light kills the shadows cast by the key light. By making the background lighter than the skin tones, the subject stands out sharply.

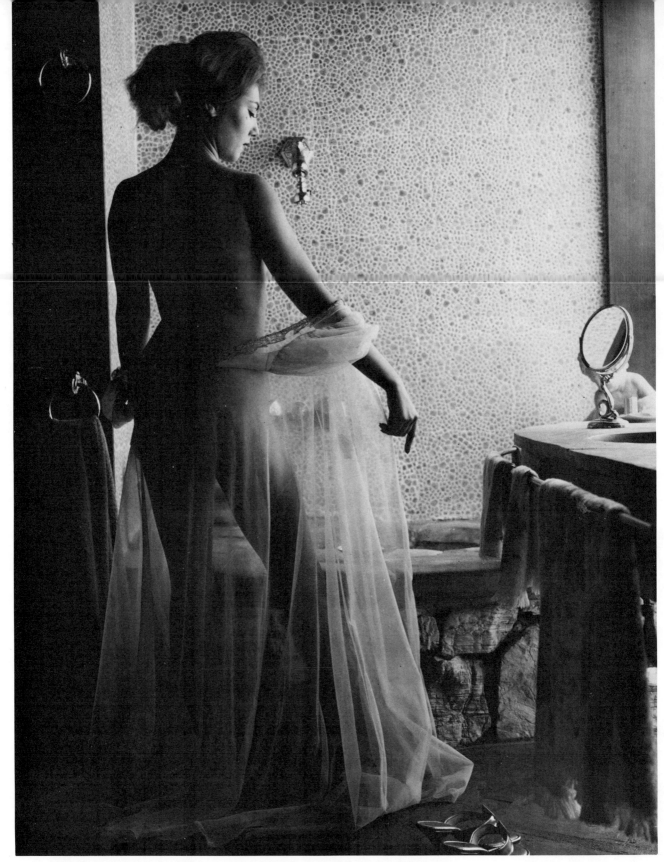

Single electronic flash placed out of camera range and to right in a small bathroom.

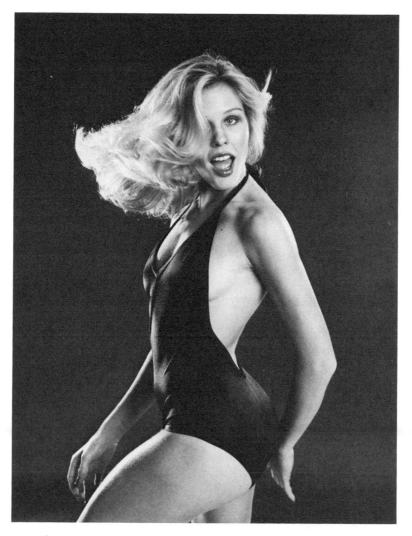

Study the lights and shadow areas to determine approximately how many lights were used and where they were placed. For this picture of model and actress Debbie Feuer, four lights were directed at Debbie from the back, one above her head (as a hair light), and one from front to light the face. Notice the way the backlighting rim-lights her body.

Anne Gowland was photographed using two lights: one on the camera, the other directed upon the white background.

Income tax day. With a self-timer, you can be your own subject! One light, placed low, and a spray gun can help produce this effect. Any Frankenstein fans in your house?

Fill Used as Backlight. Suppose you want separation between your subject and a dark background. This calls for a backlighting setup. Your key light remains near the camera, but the fill light is trained upon the subject and/or background. If the backlight is directly behind the subject, a cardboard shield may be needed to keep the light from striking the lens. Depending upon the height and position of the backlight in relation to your subject, several interesting effects are obtainable. Placed high in back of the subject, the hair will be highlighted. Placed directly behind the subject's head, a halo effect will result.

For an experiment in horror-type pictures, use the backlight in a low position, and lower the front light to a position well below the subject's chin. Frankenstein anyone?

Sidelights. Sidelighting is achieved by placing one light on each side of the subject. It is especially useful when you use a black background because it will separate your subject from the background. Try it for profile shots with the subject facing one light while the back of the head is illuminated by the other. For full-length shots, placing one light on each side and slightly in back of the subject will produce interesting variations in rim lighting.

IN SUMMARY

There are times to be artistic and times to be fast. If you can achieve both simultaneously, so much the better. But the important thing is to learn what to expect from one light used in various positions. Then consider graduating to setups involving two or more lights. Experiment with variations in lighting instead of adopting pat formulas. The more ways you can use flash as a flexible tool for interpreting a subject, the more fun you'll get out of speedlight photography.

Five-light setup, right. Four lights were used directly on model from back. The fifth light was used from the front and bounced off a 72-inch Larson Reflectasol Hex. Black shields were used to prevent the backlights from shining into the camera lens.

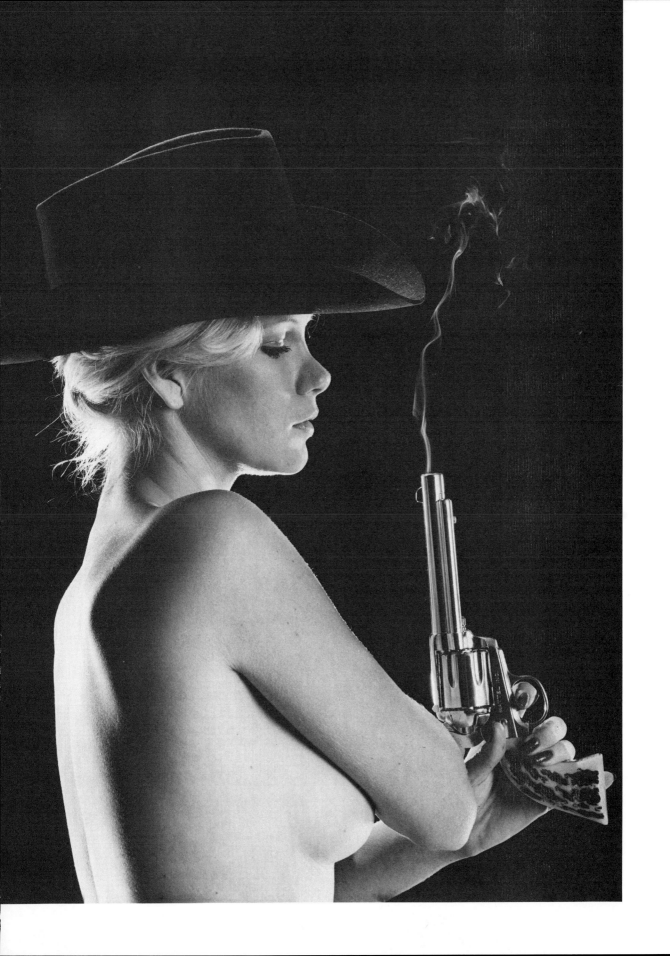

5

BOUNCE LIGHT

The flash from a single speedlight aimed directly upon a subject can be very harsh if it is not modified with another source. The sharply defined highlights and shadows it produces can be decidedly unflattering. There are times when you will want a very soft light on the high-key side in order to shorten the tonal range of separation between highlights and shadows.

Soft portraits of women and children, fashion pictures where you want to minimize wrinkles in material, and simulated available-light shots lend themselves to the use of an indirect type of light.

How can you get an indirect, soft light when you are using a hard, direct source? By bouncing, or reflecting, the flash off a light-colored surface.

What you are doing is changing the narrow spot of light into a wide, diffused area of light. Your small spot now simulates a huge flood, doing the work of the key light and fill light all in one.

THE CON SIDE OF BOUNCE FLASH

If this light is so flattering, why isn't it used more often?

There are some disadvantages.

Since reflected light cannot be as bright as direct flash, you are bound to lose exposure speed. Also, you have certain reflective condition, such as a light-colored ceiling, wall, floor, or a very large portable reflector. Remember that you must take into account the distance of flash to reflecting surface *plus* the distance of surface to subject. The exposure drop is usually about two stops. In other words, bounce flash yields only about one-quarter as much light as you would get from direct flash, based on the same light-to-subject distance.

One strobe light was bounced into a Larson Reflectasol Hex, and one small strobe was directed upon the background to kill the shadows in this studio shot of Susan Hill.

As an example, let's assume you are bouncing flash off an eight-foot ceiling. Your speedlight is directed at the ceiling from a distance of five feet. Add this to the ceiling-to-subject distance, say five more feet, and you have a total of ten feet.

With a guide number of 160 (which would call for a normal or direct flash exposure of f/16), open two stops to f/8.

With a guide number of 110 (f/11), open two stops to f/5.6.

With a guide number of 80 (f/8), open two stops to f/4.

As you can see, you need a comparatively high guide number for bounce light—either a high-powered speedlight, fast film, or both. With relatively slow film, such as Kodachrome, and a low-power flash unit, you will have to find some way of shortening the combined flash-to-reflector-to-subject distance.

This is easier said than done. A low-powered unit, for example, might give you a normal guide number of about 30 with slow color film. With a combined flash-to-reflector-to-subject distance of 6 feet, you would get a starting point of 5 (30 ÷ 6 = 5). Since the nearest f/stop is f/5.6, opening two stops will give you a shooting aperture of f/2.8.

Bounce flash yields a soft, natural daylight quality to the tones of a picture. It is flattering to subjects of all ages and to both sexes.

Needless to say, six feet won't give you much room to move about—especially when you have to have the reflecting surface at about half that distance, or three feet from the subject.

ADVANTAGES OF FAST FILMS

But the photographer with a low-powered flash unit can still get excellent results when he figures the advantage of using a high-speed daylight film. An ASA rating of 200, 400, 800, or even 1600 can give you some very high guide numbers, and if necessary these can be extended by special developing procedures.

To establish the exact exposure for your own particular unit, film, and reflecting surface, you may take the following steps:

1. Position your subject so that a total distance of ten feet exists between the flash, reflecting surface, and subject.
2. Make a series of exposures starting at the widest f/stop. Each exposure should be one stop less than the last.
3. Record this data on paper, or include a card in the picture so you will know the exact exposure later.
4. After your film is developed, pick the correctly exposed picture.

Remember, with a small flash unit you will have to have a very fast lens when using a slow film.

Right, daylight effect was obtained by bouncing light from the flash off the ceiling. Note the use of light-colored walls and floor.

Proper exposure for bounce-light pictures requires experience. Take at least four test shots with cards to identify f/stops used.

REFLECTING SURFACES

Many bounce pictures are made with the light directed at the ceiling, either above the photographer, above the model, or somewhere in between. Although this is good practice, there are interesting possibilities in using other reflective surfaces.

Ceiling Behind Model. Dramatic silhouettes can be made by bouncing your speedlight against the ceiling *behind* the model. (You will need either a stand or someone to hold the unit for you, and a long synchronizing cord for off-camera shots of this type.) The silhouette effect is created by having most of the light bounce off the ceiling and background *behind* the subject.

Wall Behind the Camera. For your flattest light, try bouncing the flash off a wall *behind the camera.* Here you will have practically no shadows, and the lighting effect will be almost directly opposite that of using the ceiling behind the subject. Remember to check your flash-to-wall-to-subject distance because the wall behind the camera is likely to be farther away than the ceiling. The flatter the light, the more contrast you will need in black-and-white developing. We will discuss special developing in a later chapter.

Light can be bounced from many different types of surfaces: a wall, a ceiling, a large reflector, a sheet, a piece of white plywood, and the like. However, it is the placement of the light(s) that determines where the shadows will fall. This series of pictures depicts four basic lighting positions. The model is Robin Mattson.

In these four pictures, light was bounced from an area above and behind the camera.

Silvi Jones. Model and cub photographed at Lion Country Safari, Laguna Hills, in an open end barn. We used a 36″ Larson reflectasol (super silver) and bounced a 200-watt-second Norman portable strobe unit into it. Pentax camera.

(Left) Diane Zapanta. Photographed with 4 × 5 Gowlandflex with 210mm lenses. Other equipment: 4 lights directed onto a white background, a 200-watt-second hair light, a 72″ Larson reflectasol as key light, and an 800-watt-second Norman strobe. (Below) Ava DeLa Sabliere. This rug ad was photographed with 4 × 5 Gowlandflex, 72″ Larson reflectasol hex as key light, and direct flash aimed toward the background.

(Above) Diane Zapanta. Picture taken at Santa Monica beach with 4 × 5 Gowlandflex with 210mm lenses, with hand-held 200-watt-second Norman portable strobe. 1/250 sec., f/16, Ektachrome daylight. (Right) Jean Manson. Green lawn at the Gowland home was illuminated by sunlight and used as background. The electronic flash, a 200-watt-second Norman portable strobe, was placed 8' from model to balance exposure.

Suzanne Copeland. Photographed against a black background with five backlights—two on each side and one on the hair. Front key light was a 72" Larson reflectasol hex. 5 × 7 Gowlandflex with 240mm lenses.

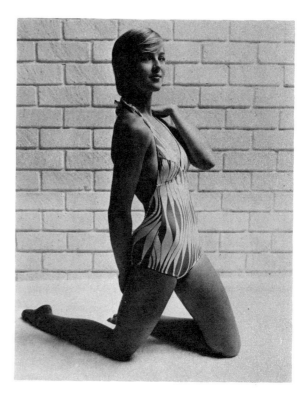

Here, the light was bounced from an area above
the model.

Light was bounced from the camera right and
low for the pictures below.

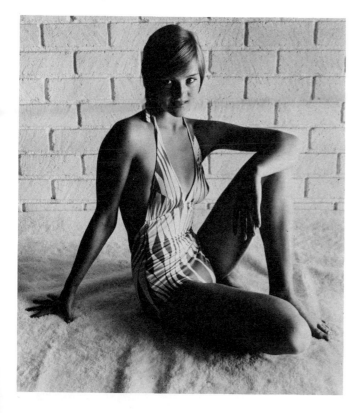

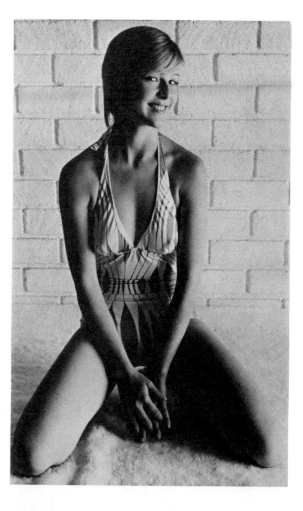

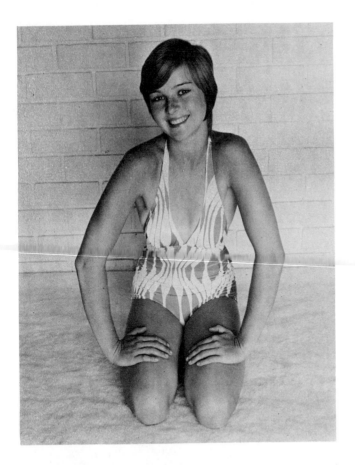

For these pictures, the light was bounced from a low angle directly behind the camera.

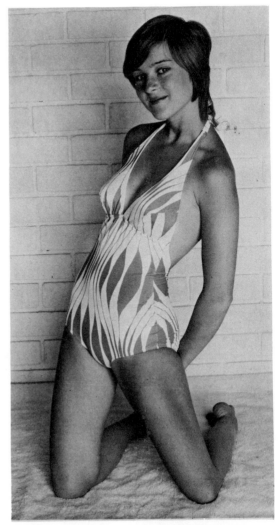

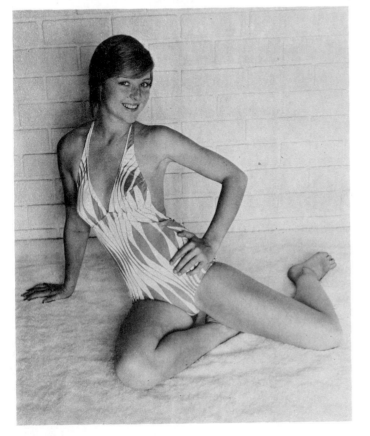

Side Wall Bounce. With sidelighting of this type, you will get more roundness or third-dimensionality than when using typical above-the-camera bounce. The shadows on the side of the subject away from the lighted wall may be desirable for certain types of pictures. For example, you may want a subject's face turned towards the shadows in the case of the full-length nude. Here you are creating an effect and are using shadows to depersonalize the picture.

Floor Bounce. Just for fun, you might like to try floor bounce. You will need a very light carpet or floor covering. A white sheet will substitute, if necessary.

For the utmost in bounce light, a large reflector will give you maximum control. Here you can place the reflector at the perfect angle and distance from the subject.

For closeups, the ideal bounce reflector might be 3–4 feet square. For the full-length picture, a reflector 6′ × 6′ or larger is required. I have found umbrellas a good substitute for flat reflectors because they can be folded for traveling, and the shape is more efficient for reflecting light. I use many Reflectasols made by Larson Enterprises, P.O. Box 8705, Fountain Valley, Ca. 92708. They are reversible so that the bright or dull side can be used. The softness and broad light source is very flattering when used alone on portraits. I generally use the smaller umbrellas for closeups and two large 36-inch ones for full lengths. Another favorite technique of late is to use two 36-inch umbrellas for a key light at the side of the camera, which the model is facing, and to use the 36-inch, reversed to the dull side, next to the lens as a fill-in light.

Here's a daylight flash technique worth adding to your bag of tricks. Instead of lighting Leigh Christian's face, left, with direct flash, I bounced the light off a white reflector from the side. Note the difference in tone quality between this and the photos using the sync-sun technique. The same technique was used on the backlit picture of Karen Mayhay, below.

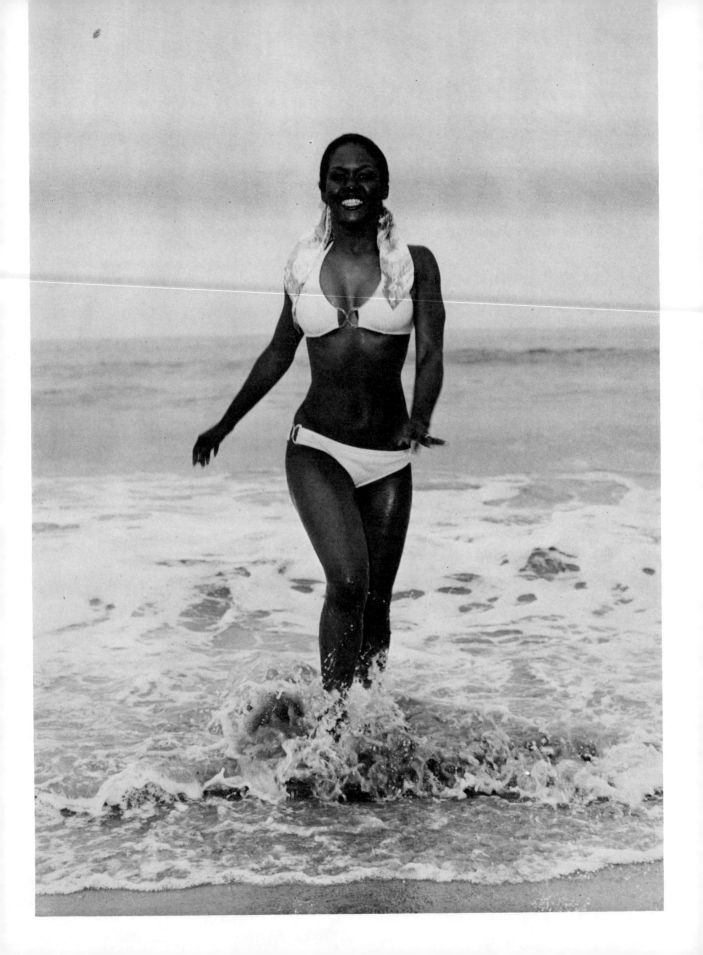

6

SYNC-SUN

Bright, direct sunlight is a point source of light and can cast hard, unflattering shadows. In the early days of photography, metal-foil reflectors were used to fill in these shadow areas. Later on, flashbulb fill became popular.

Most reflectors are awkward to carry and almost impossible to face without squinting. Although flashbulbs solved the squinting problem, they proved expensive.

Electronic flash is today's answer to sun control because its color quality closely approximates that of daylight.

Since many people take pictures when the sun is high overhead, their subjects often have black holes for eyes and deep shadows under the nose and chin. It's a common misunderstanding that a bright day requires no use of flash. In fact, I've had people stop me at the beach and inquire why I was using a flash when the day was so bright and clear. It's true that if one is taking a scenic shot or seeking very dramatic shadowy effects, flash is superfluous. But when photographing human subjects with sun overhead, a fill-in light is necessary to subdue the black, unflattering shadows.

At other times of day, when the sun is coming from a low angle and crosslighting the subject, a flash fill often provides a pleasing result without washing out the shadows completely.

Then, too, if your subject finds it impossible to face the sun without squinting, you can always use old Sol as a backlight and let your flash provide the key light that il-

A single flash on the camera was used to illuminate the shadow areas in the sync-sun shot of Debbie Creger, above. By varying the exposure, it is possible to lighten or darken the background to suit the mood of the picture.

luminates the near side of your subject. In short, flash can create the illusion of sunlight without the discomforts of sunlight.

SUN AS A BACKLIGHT

When using your electronic flash as the key light and the sun as the backlight, this is how you arrive at the correct distance at which the flash should be placed: First, determine the normal sunlight exposure for your picture. This can be based upon either an exposure-meter reading or the instruction slip that came with your film. Once you have the sunlight exposure, say f/16 (using black-and-white film), divide 16 into your flash guide number to find the distance at which to place the flash.

Now, suppose the flash is attached to the camera and can't be removed to alter the camera-to-subject distances. In this case, adjust your basic f/stop exposure for the camera-to-subject distance you want. In so doing, remember this rule: For each number you close down the f/stop opening, you must lengthen your shutter speed to the next number. This is so that your background will still be properly exposed. Conversely, for each full stop you open the lens aperture, you must use a faster shutter speed by one full number.

When working in the surf, I plan the action ahead of time. Left, model Cindi Cook runs toward the camera, which was prefocused. A Hasselblad was used for this black-and-white shot.

Here is the synchro-sunlight chart I use for black-and-white film (ASA 125) with a small flash unit that gives me a guide number of 110:

Right, Emily Oliver poses in the shade of a building with sun in the background. To balance the two extremes, a Honeywell Strobonar was used on the camera.

Medium-Speed Black-and-White Synchro-Sun Chart

Distance (flash-to-subject)	f/stop	Shutter Speed
5 feet	f/22	1/50 sec.
7 foot	f/16	1/100 sec.
10 feet	f/11	1/200 sec.
15 feet	f/8	1/500 sec.

There are times when flash is not necessary. For instance, this photo of Abbey Lee was taken late in the day when the sun was low on the horizon.

Using the Kodachromes or Ektachrome-X, the chart below is for a guide number of 35, which is about average for a small electronic flash unit:

Kodachrome/Ektachrome Synchro-Sun Chart

Distance	Koda-chrome 25	Koda-chrome 64 Ektachrome-X	Shutter Speed
13 feet	f/16	f/22	1/30 sec.
4½ feet	f/11	f/16	1/60 sec.
6 feet	f/8	f/11	1/125 sec.
8½ feet	f/5.6	f/8	1/250 sec.
12 feet	f/4	f/5.6	1/500 sec.

Background exposure can be controlled by over- or underexposing it according to the effect you want. Instead of a dark blue sky, for instance, you might want a high-key effect. It's possible to make the sky white by overexposure, yet keep your subject correctly exposed.

Since you are using the flash as a fill light in most cases, it is best to leave the speedlight on the camera. Remember that when you *do* use flash as your key light, it will create shadows outdoors the same as it does indoors. If held too high, it will cause the shadow of a subject's nose to meet the lips—which is decidedly unflattering. Slightly higher than the direction in which the subject is looking is the best position for the speedlight.

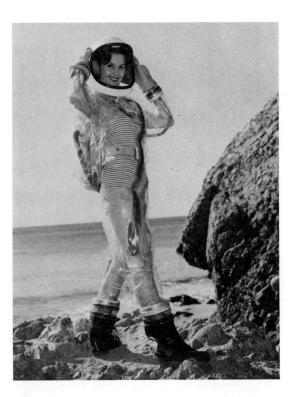

Left, flash solves the problem of getting light into the helmet to show the lovely face of Charline James, would-be female astronaut. Right, contrast is built up by using flash on an overcast day. Model is April Satow.

Problem: To photograph Jean Manson leaning on a tree in dense shade against bright backlighting. Solution: Balanced speedlight flash exposure.

7

SYNC-SHADE

With bright sun, electronic flash is usually used as a fill-in light to soften deep shadow areas. With shade light, flash is often used for the opposite reason—to create shadows that give the picture more gradations of tone and contrast.

In each case, everything depends upon the position and angle of the speedlight. In bright sunlight, the flash is generally used near the lens to soften the cross shadows; in shade, you may want to take the flash head off the camera and hold it at arm's length in order to get some distinct shadows on the face and figure.

In photographing girls, I try to remember the way a key light affects the face and figure:

1. For the face—try not to have the flash so high that it casts a nose shadow over the upper lip.
2. For the body—you will usually get the best crosslighting for the bust when the key light is on the same side of the camera as the shoulder closest the camera. In other words, crosslight at 45 degrees from the front.

With a single key light at the camera, you can combine good face lighting with good body lighting by turning the body three-quarters to the camera and having the face turned straight toward the key light. This will enable you to combine flatteringly flat face light with attractive crosslighting for the body.

BALANCE THE BACKGROUND

In using shade lighting under trees, you may encounter the problem of arriving at an exposure between the dark shadow below the trees and the bright sky in the background. Here is where speedlight can help

Alice Gowland adjusts model's bathing suit while Peter Gowland checks the angle of the 5″ x 7″ Gowlandflex. Peter uses this larger film format for most of his commercial color work. The model is Diane Parkinson.

you. Rather than expose for the deep shadows and let the background burn up, you can expose for the background and use your flash from a distance calculated to balance the two exposures.

The procedure is the same as discussed in Chapter 6. With backlighting you have the choice of either adjusting your camera's lens opening (f/stop) for a certain flash distance or using a flash-to-subject distance compatible with a given lens opening.

Remember that special effects can be obtained by either having your background over- or underexposed. In color, night effects are the result of underexposure, while a bright daylight effect is the result of overexposure. With black-and-white films, of course, you get the same effect when you make prints from under- and overexposed negatives.

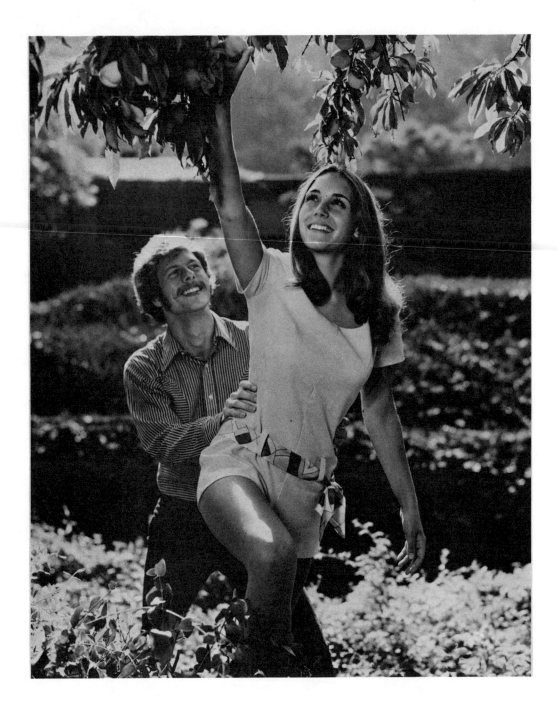

Working under and around trees can create problems both of lighting and of cluttered backgrounds. Here, the problems were solved by lighting the subjects with flash from the front and by making sure that the backlighting separated them from the cluttered background.

SPEEDLIGHT AND WINDOWLIGHT

There may be times when you want to use windowlight for a bright background and speedlight to illuminate the shadow side of your subject. Here, again, you must arrive at an exposure balance compatible with the two light sources.

And again, placement of the light will depend upon the pose and the direction the subject is facing.

I have found that the larger the window, the better the picture. We are lucky here in California because so many homes have at least one wall of floor-to-ceiling glass. It is practically like shooting outdoors.

We've found occasion to use almost every kind of window, including a stained-glass church pane that came in handy for a double-exposure shot of a choir-girl scene. Windows with many panes tend to complement period-type costumes, while solid glass, floor-to-ceiling expanses make perfect settings for modern costumes.

Regardless of the size of windows involved, you must make exposure allowance for the light they admit. If you don't, the picture will look as though it were taken at night. By compensating, you are taking advantage of two different light sources—depending upon the windowlight to separate the subject from the background and flash to provide front illumination.

BOUNCE LIGHT AND WINDOWLIGHT

Since most windowlight is indirect and soft, a more natural effect can be obtained by using bounce light rather than direct flash. Then, too, there are times when direct flash will completely overpower the windowlight unless you either move the unit way back or use a slow shutter speed for low-level windowlight. Bounce light is the ideal answer to this problem.

Your exposure for bounce light will, of course, depend upon the distance of the flash unit to the reflecting surface *plus* the distance between the reflecting surface and the subject. Remember to open up at least two stops when you divide the combined distances into your regular guide number.

The following comparison will give you an idea of the exposure differences you can expect when you switch from direct flash to bounce light:

Suppose you are working with direct speedlight at a flash-to-subject distance of 5 feet and a guide number of 110. Your lens opening is *f*/22 (110 divided by 5 equals *f*/22). This would be fine as long as you had brilliant sunlight shining through the win-

John Dierkes was illuminated by flash on one side and windowlight on the other. Can you tell which side received which light?

dow. But what if you happened to be getting shade light from the window? Your shutter speed might have to be as slow as 1/10 sec. at *f*/22 in order to balance the shade light from the window with the flash.

With bounce light, still using a guide number of 110, you could open up to *f*/5.6 and use a comparatively fast shutter of 1/50 sec. Here is how it works:

With the unit aimed so the light travels five feet to the ceiling, then bounces five feet back to the subject, you have a total of ten feet of distance for the light to travel. With a guide number of 110, the normal lens opening would be *f*/11. For bounce, you open two stops to *f*/5.6.

Bounce Guide Examples

Guide Number	40	56	80	110	160	220
Divide by 10 ft.	*f*/4	*f*/5.6	*f*/8	*f*/11	*f*/16	*f*/22
Open 2 Stops*	*f*/2	*f*/2.8	*f*/4	*f*/5.6	*f*/8	*f*/11

Based on white ceiling with total distance of 10 feet, unit-to-ceiling-to-subject.

GHOST IMAGES

There is one major benefit to using a fast shutter when combining *sustained* light with electronic flash. As we pointed out earlier, your speedlight has a duration of *at least* 1/250 sec. Your sustained light exists for the duration of your shutter setting, anywhere from 1 second to 1/500 sec., depending upon your camera settings. With a "time" or "bulb" setting it can be for any length of time you choose. Obviously, two independent light sources are recording images simultaneously when you take a combined speedlight-and-sustained-light exposure. Your flash duration registers an image at one speed, while the sustained light is making an exposure at another.

All is fine as long as the subject remains still for the longer exposure. If your subject moves, two images may be recorded on the film. The flash image will be sharply defined, but the sustained-light image will be blurred. The faster the movement or the slower the shutter, the more blurring there will be. These are "ghost" images.

When using daylight, floodlight, or available light in conjunction with electronic flash, think in terms of the *sustained light* when you select shutter speeds. When there is action, use the fastest shutter you can in the interest of sharpness.

There are exceptions, always. When a special effect is desired, you may want to experiment with a slow shutter and fast action, or try a single flash exposure combined with double or triple sustained-light exposures.

Just be sure that the ghosts in your pictures are the tamed, garden variety who show up by invitation. It's the unexpected, renegade ghosts who spoil the party.

To balance the windowlight in this picture of Misty Rowe, left, Gowland bounced one strobe off a 36-inch Larson Super Silver Reflectasol.

This unusual lighting effect
was achieved by placing the
strobe lights to one side of
the model and bouncing
them from two 36-inch
Larson Super Silver
Reflectasols. Kodak 2475
Recording Film (Estar-AH
Base) was used to produce
graininess.

8

MULTIPLE ELECTRONIC FLASH

The term "multiple flash" refers to the use of two or more light sources that are triggered simultaneously when an exposure is made.

Although the use of multiple speedlight is commonly thought of as a professional technique, many amateur photographers are taking advantage of the extra light control this system has to offer. There are a number of ways in which multiple-light setups can be achieved. Among them:

1. You can buy a unit that has an outlet for plugging in an extra head. When the light is divided, the speed of the flash is twice as fast—1/500 sec. becomes 1/1000 sec.

2. One or more comparatively inexpensive slave-light units may be used to supplement your key lights.

3. There are many studio AC units on the market that have provisions for heads to be plugged into a single power pack. One of my units, for example, allows four lights to be used on one power pack. The total output is 800 watt-seconds so that when two lights are used each gives 400 watt-seconds; with four lights you get 200 watt-seconds each. Although this is not a cheap unit, the price is most reasonable when you consider the light distribution you're getting.

PHOTO EYES

Any photographer considering the purchase of a studio AC unit with several auxiliary lights should also consider the use of photo eyes (slave units). Although the use of a central power pack with several lights is cheaper, I prefer several power packs with photo eyes. The reason for this is the heavy wires between the units are eliminat-

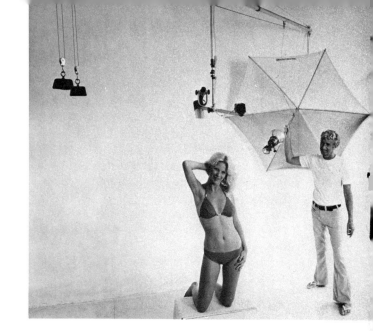

Peter Gowland is shown adjusting his new Gowland Swing Light, manufactured by Larson Enterprises, Inc. A Norman 800 watt-second power pack supplies power to the 72-inch super-silver Larson Hex. The entire unit is attached to the ceiling of the studio, directly above the subject. It swings in an 18-foot circle and can be adjusted high or low merely by the light touch of the hand, because it is counter-balanced. Hairlight in the center rotates in a 3-foot circle and is a slave to the larger light. No wires are on the floor, instead all wires are in the ceiling.

ed. The fewer wires on the floor, the less danger there is of tripping.

Today my studio setup consists of 1 P800 Norman Power Supply, which delivers 800 watt-seconds. This is mounted behind the camera and connected to a six-foot Larson Reflectasol Hex, which hangs from the ceiling. One of these Reflectasols hangs on either side of the camera, and the power pack can be connected to either one. This power supply recycles in a quick 1½ seconds to 100 percent voltage-stabilized output on full power and in only 0.6 second to 100 percent voltage-stabilized output on low power.

To keep the floor wires to a minimum, two lamp heads are attached to two stands,

each of which carries a power pack. These stands are used to light the background, providing exceptionally even background illumination from a total of four lights. A single wire from each stand runs to the AC wall plug. A photo eye on each power pack fires the four background lights.

The third power pack is used on the stand for the key light, which is fired by a wire running to the shutter.

To recap, this is the lighting setup we use for most of our commercial cover shots: four lights mounted on two stands on the background and one light in front. There is one more light I haven't mentioned—a boom light that is used on the hair.

COMMERCIAL LIGHTING

Why is it necessary to use six lights to get a good picture?

It isn't. Good pictures can be made with only one light, as we described earlier. But in commercial color photography, you need bright color and an evenness of light. I have found that at least two front lights are required on the subject in order to obtain the proper modeling and fill-in.

Many photographers use three: a key and two fill lights—one on each side of the camera. The lights are placed at 3 different distances such as key right, 7 feet; first fill left, 10 feet; second fill right, 14 feet.

Picture of Lorraine Zax was made with a simple four-light setup. Note highlights in her eyes from key light. Remaining lights, one on each side, illuminated the background and the hair.

Seven flash heads were used to get even light distribution for this 5″ x 7″ color portrait. Camera was the Gowlandflex.

PLACEMENT OF KEY AND SECOND FILL

In other words, the distance doesn't matter as long as the ratio is maintained. The key and the second fill lights are used on the same side of the camera, with the fill at twice the distance of the key. The first fill is used at a distance in between. Here are several possible combinations:

Three-Light Front Lighting

Key (right)	First fill (left)	Second fill (right)
3 feet	4½ feet	6 feet
4 feet	6 feet	8 feet
5 feet	7½ feet	10 feet
6 feet	9 feet	12 feet
7 feet	10½ feet	14 feet
8 feet	12 feet	16 feet

For this picture of Fiona Gordon (left), Gowland used a 72-inch Larson super-silver reflectasol Hex slightly left of the camera and a Honeywell 880 strobonar slave behind the curtain directed against the background.

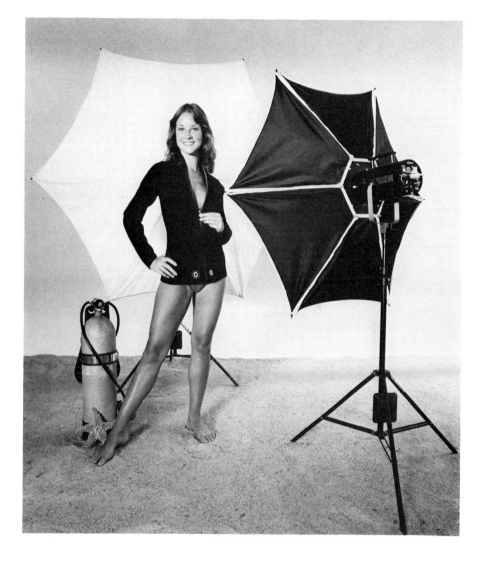

Latest Larson equipment is this pair of "Starfish" light units. Using a VK-8000 Strobasol on each unit, the black side of the 52-inch Starfish is shown in the foreground and the white side of the 72-inch Starfish is shown in back of the model, Joni Goulet. The light is contained within the units. It bounces against the inside which is super-silver, then is diffused by the translucent material, thus giving out a wide, soft light and eliminating the necessity of a fill light.

Left, one light was used behind model Judy Monterey. A bare bulb lightened the hair, and a single flash was placed in front. Right, photograph combined bounce light from the front, a hair light from the back, and daylight in the background through the window. Lovely Beverly Gill is the model. Picture was taken with the Hasselblad.

Key light is used in any position that provides pleasing modeling to the face or figure, usually to one side of the camera and above the lens level. I have found that a lower key light is better for smiling expressions than when the face is in repose. This is because you want all the light you can get on the teeth. Moreover, when a person smiles, fewer wrinkles are emphasized by head-level lighting than by above-the-head light.

Both fill lights should be kept as close as possible to the camera axis so as not to throw a second shadow. All you are trying to do with the fill-in lights is soften the shadows of the key.

As mentioned above, this type of lighting is for commercial color photography where very soft shadows are required. The color itself provides the separation. In black-and-white photography, where *tone* provides the separation, the lighting can be more

dramatic. That is why good black-and-white pictures can be made with a single light. At the most, one fill-in source is all that is essential.

BACKGROUND

Why are four lights necessary for the background? For many pictures, they aren't. In black-and-white, a single background light will give you pleasing tonal gradations. If you place the background light directly behind the subject, the bright area that helps delineate the subject will gradually darken towards the edges of the picture.

With color, a single background light placed directly behind the subject may give you more darkened area than you want. Two lights will give you a more evenly lighted background, but to get the background really even, four must be used. This is espe-

*Four lights were directed onto the background,
and one was aimed at Diane Parkinson.*

cially true in shooting full-length pictures.

There you have it—seven or eight speed-lights. This is one reason why many photographers resort to bounce light—to get a soft, overall evenness with fewer light sources.

A favorite of mine (and also popular with magazine and calendar editors) is the completely black background. But strange as it seems, it requires almost as many lights to work with a black background shot as it does with a white background!

Very few good pictures result from posing a subject against a black background and using only front lighting. Reason: There is no separation between the edges of the face or figure from the black. They seem to melt into the darkness all around the edges. In black-and-white photography, detail is lost. In color, the color itself is washed out.

BACKLIGHTING

The answer: Backlighting. The face or figure must be completely edged in a rim of bright light. A face needs at least three lights: one for the hair and one on each side of the face. The body shots need two more, with one on each side. Add to this two front lights, and we are back to seven lights again!

Since some of these lights must be placed *behind* the subject in order to produce edge lighting, the flash will be directed into the lens. Hence a shield of some type must be used to prevent halation. I prefer a framework that forms a "doorway" around the model. In Hollywood studios, cloth-covered wood or metal frames are called "gobos." You can build your own gobos by making a wooden frame of $3/4'' \times 1^{1}/_{2}''$ pine and tacking black cloth over it. A couple of panels about 18 inches wide and 6 feet tall will keep the sidelights from striking the lens, while an additional smaller panel $1^{1}/_{2}' \times 4'$ can be used across the top to hold back the hair light. A couple of light clamps will hold the small panel in place.

An even easier way to keep backlight out of the lens is to clamp pieces of cardboard to light stands. You will need either a long, narrow panel for each side or one piece of cardboard for each light used.

BACKLIGHT EXPOSURE

It isn't necessary to maintain perfect exposure with your backlights; in fact you are better off with an overexposure than with a normal one. Since backlight is only a small portion of the subject area, you will want this portion to stand out. Overexposure makes this possible.

Your exposure should be based entirely upon your front light or lights.

MULTIPLE EXPOSURES

Interesting multiple exposures can be made with only one or two lights. Here is how it's done:

1. Select a room that can be darkened against daylight. Then pose your subject against a black background.
2. Allow ample background area for the several different exposures you intend to make. If you have a groundglass camera, the individual exposure areas can be outlined on the groundglass with grease pencil. If you don't have a groundglass, you will have to remember various positions. A pencil sketch may help.
3. Arrange your lights so that the least possible amount of illumination reaches the background itself. Reason: Even the blackest black will record on the film if it is subjected to repeated flashes of light from various angles.
4. Extinguish your room lights (to avoid any possibility of ghost images) and take your first flash exposure. Then, without advancing your film to the next frame, have your subject assume a different pose and position for the second exposure. Repeat this procedure for as many images as you want to record in the negative area you have to work with.

Right, three single-flash exposures made on the same negative. Below, Cara Dodge poses for this combination of one flash without diffusion and a second, diffused flash near the camera.

9

ACTION WITH ELECTRONIC FLASH

Action of any kind, no matter how slight, adds interest to a picture. You might even say that a smile is a mild form of action. In the more strenuous forms of action, you can range from candid photography of all types through acrobatics, dancing pictures, and sports coverage. Whatever the action may be, it is the antithesis of a static pose.

Each type of action requires a different camera technique, but due to its short duration of light, electronic flash is ideal for recording anything from a fleeting expression to an Olympic triumph.

With most electronic flash units, you have a minimum flash duration of 1/500 sec., so there is very little action that cannot be stopped by the flash alone. Indoors (where there is little existing light), you have no problem because the speedlight itself freezes the action. Outdoors, your only problem is the possibility of ghost images.

As discussed in Chapter 7, a ghost image may occur when there is existing light and you use a slow shutter speed in conjunction with speedlight. In action pictures, the ghost image appears as a blur when the camera records one image by the existing light, say 1/50 sec., and a second sharp image with a speedlight exposure of 1/500 sec. The best anti-ghost remedy for outdoor speedlight pictures is a fast shutter speed, where it is possible.

A pretty girl, sync-sun illumination, and interesting motion of the water are a hard combination to beat. (Left) Kathy Morrison enjoys posing at the ocean.

PEAK ACTION

When working outdoors with a dancer or in shooting sporting events, use only the fast shutter speeds: 1/250 sec., 1/500 sec., and 1/1000 sec. Most action can be sufficiently stopped—and the danger of ghost images minimized—at 1/500 sec. If your camera only syncs at 1/60 sec. or 1/125 sec., it is possible to take fast action pictures if you use the "peak-action" technique. To do this you simply anticipate when the split-second pause at the height of the action will take place. In working with a dancer, this is fairly easy because you can have your subject go through the motions several times before taking an exposure. In this way you can estimate when and where the peak of action will take place. Even so, it is advisable to take a series of exposures of each different leap or movement to make sure you caught it at exactly the right second.

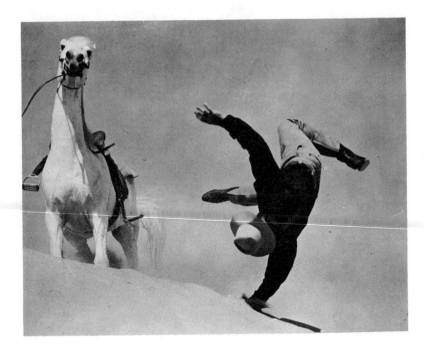

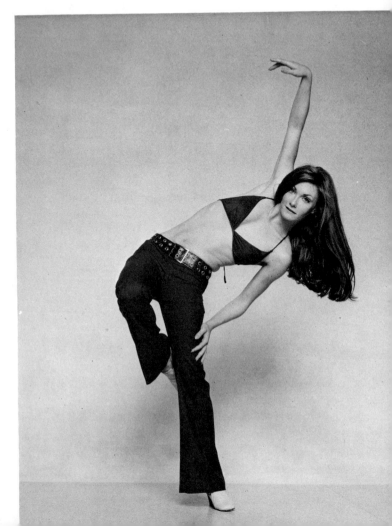

Impact. Although both of these shots were posed, they required a lot of careful planning, lighting, and timing. It's possible to freeze action too much with the speed of electronic flash.

PREFOCUSING

The direction of motion has a lot to do with whether or not the shutter can stop it. It is much easier to get a sharp picture of a subject moving either toward or away from the camera, than moving across the field of view. In other words, a shutter speed of 1/100 sec. might stop a runner coming toward the lens, but 1/500 sec. or 1/1000 sec. might be required if he were traveling across the field of view.

One way to help make certain of getting a good action shot is to mark the spot where the peak action will take place. You focus your camera on a marked spot, have your subject take a few steps back, and then bring the action to a climax at the indicated mark. A typical example of this might be to have a boy pass a football while running toward the camera. The timing of the pass, your shutter finger, and the focus might all be out of sync if you failed to decide *beforehand* where the action was to take place.

EXCEPTIONS

There are occasions when preplanning is difficult or impossible. The action happens so fast, without warning, that there is no time to prepare for it.

A case in point is a photographic series I did for DuPont. Most of the series involved violent action—a picture of a fight on the edge of a pier with one man being knocked backwards into the water; a picture of a man falling off a horse; a picture of a man flying through a glass window; and a picture of a man breaking a bottle over another man's head.

The last shot was the toughest. The wrist travels only a few inches during the whole breaking operation, so there was very little opportunity to anticipate. We had only one plastic prop bottle—the kind that is specially designed to break very easily. I took the picture, uncertain as to whether or not I had triggered the speedlight at the exact second the bottle struck the man's head. Sure enough, my reaction had been about 1/25 sec. too late. In the picture, the bottle had shattered beyond the point of even looking like a bottle.

In retrospect, I now know exactly what I should have done. There are at least two ways of taking this type of picture with assurance that the speedlight and action will be in perfect sync.

TWO-WAY HINDSIGHT

One way would have been to place electric contacts inside the hat. When the bottle struck, the contacts would have fired the flash. This method would have required the use of an open shutter in a room darkened to prevent recording a ghost image.

Another way would have been to use a microphone adjusted to trip the electronic flash at the sound of the breaking bottle. The millisecond delay between the shattering of the bottle and the time it took the sound to reach the microphone would be negligible. In fact, a certain amount of delay would be needed in order to show the bottle in flying fragments.

Annette Molen in a sync-sun action shot. Don't hesitate to try a variety of camera angles in order to dramatize action. This is a medium-height shot, but I often shoot from water level or even pack a stepladder for taking high-angle shots.

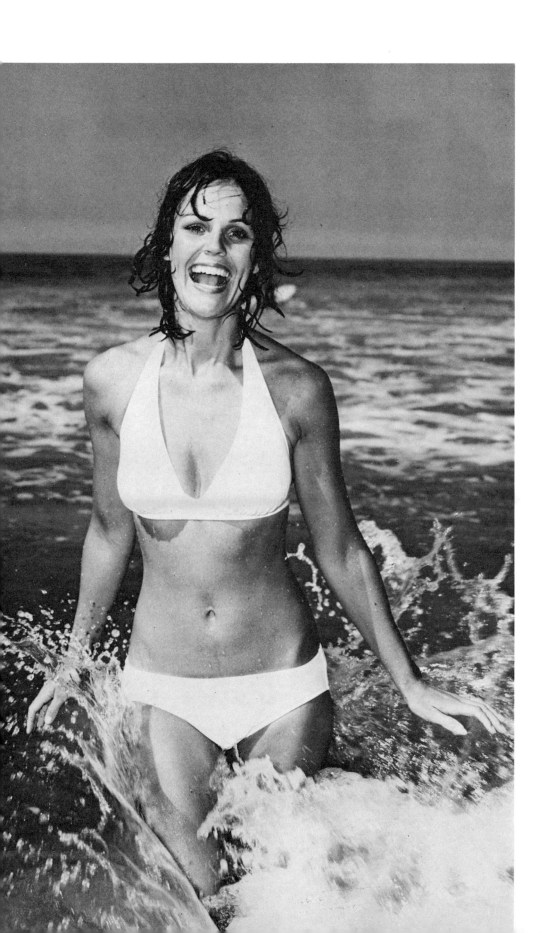

Catching children in relaxed and natural poses is more easily achieved when using electronic flash. With it, you can capture the nuances of expression rapidly and at a minimum cost.

10

BLACK-AND-WHITE TECHNIQUE

If electronic flash is new to you, you will probably be surprised at how much easier it is to use than you expected. In fact, picture making per se will become a lot easier.

When electronic flash was first introduced, there was much talk of how "soft" the light was and how the negative needed special development in order to make a normal print. In those days, flash durations were 1/5000 sec. to 1/10,000 sec., and the light produced by many units was relatively weak. Today, the flash duration is longer, and the quality of the light is quite compatible with modern emulsions.

Since I process eight rolls of film at a time and may have sunlight, tungsten light, and regular (direct) electronic flash represented in each roll, all my black-and-white films are dunked in the same developer. The slightly softer contrast I sometimes note in the speedlight negatives presents no printing problem.

If you have a chance to develop speedlight negatives separately (from negatives exposed by other types of light) or if you enjoy darkroom experimentation, you may want to increase the contrast in your negatives by overdeveloping them up to 20 percent.

Peter Gowland and assistant Mike Mullikin work with a 4"x 5" Gowlandflex and a Norman portable strobe unit, which has a 200 watt-second output and a 1-second recycling time. The camera is mounted on the Gowland stand for convenience. However, it is often hand-held for both the 4"x 5" and 5"x 7" formats.

BOUNCE LIGHT

Overdevelopment is almost always desirable in processing bounce-light negatives, regardless of what type of source you use. Floods, flashbulbs, or speedlight all lose contrast when the rays are diffused by reflection over a wide surface. The same holds true when you take pictures in the shade or when there is an overcast sky; the diffused light reaches the subject from every direction so that there are no definite shadows. If you overexpose a black-and-white negative, it will have a fogged appearance and print badly. The way to avoid the fogged effect is to underexpose the negative—then increase its contrast with overdevelopment.

In our lab we use two different black-and-white developers: one for medium contrast and one for low contrast.

By now you can easily tell how many flash heads were used in making simple closeups like these. Just count the highlights in each subject's eyes.

MEDIUM-CONTRAST DEVELOPER

We use negative sizes ranging from 35mm to 5" × 7". The *average* negative exposed by sunlight, floodlight, shade light, and electronic flash is run through our medium-contrast developer (which happens to be D-76). Variations in contrast are compensated for by changing the time of the development. Depending upon the original exposure and degree of contrast desired, developing time varies from 6–8 minutes at 70°F. Developing time also varies according to the brand of film being processed. You must change time for film characteristics as well as for contrast.

To keep things on the simple side, I rec-

ommend a standardization in film brands as well as in development. Unless you know in advance what to expect from your combination of film developer and speedlight, how can you be sure of the results? When you find a combination that does the job for *you,* stick to it.

We use Verichrome Pan for most of our size 120 black-and-whites, and Plus-X for most of our 35mm black-and-whites. We like Verichrome Pan and Plus-X film (which can be pushed if necessary) because they are medium-speed, fine-grain films that yield medium contrast.

I, personally, feel that the very slow films have too much contrast, while the ultra-high-speed films are too soft and grainy.

Left, using a black background with a girl who has dark hair requires a hair light to separate her hair from the background. Right, using bounce flash from camera right and fill-in light for the face captures Ann Cushing.

LOW-CONTRAST DEVELOPER

Our low-contrast and high-contrast developers are used only for copy work. The problem in copying full-tone work, such as black-and-white photographs or color transparencies, is holding down the contrast. We use D-23, a soft-working, two-part developer.

D-23 Part "A"			D-23 Part "B"		
Water	3 liters	125° F.	Water	3 liters	125° F.
Methol	30 grams		Kadalk	40 grams	
Sulfite	400 grams		Water to make	4 liters	
Water to make	4 liters				

SIMPLE BLACK-AND-WHITE TECHNIQUE

A Good Background is an important part of any picture because it can either emphasize or detract from the subject. Make sure your subject stands out clearly against the background *before* you shoot.

Lighting can enhance or spoil the way the subject records. Know where to position your lights so they can be used to an advantage.

Props can be very important to the final result. Choose props that fit the situation and help to give your subject something to do.

Clothing and Costumes should always be in good taste and in keeping with the theme of the picture.

Print Quality is directly related to exposure and development. Add to this critical focus, correct framing, and composition. Finally, care in handling the negative is essential in avoiding fingerprints, dust, scratches, and a host of other print-soiling blemishes that are the trademark of poor craftsmanship.

Develop 2–10 minutes in part "A" at 68° F. Develop for at least four minutes in part "B." *Or* develop 10 minutes in part "A" without part "B" for normal negatives.

Electronic flash, incidentally, is ideal for copy work. Since the light is of extremely short duration, it tends to minimize contrast. Speedlight can also be used for regular reflection-copy jobs (black-and-white photographs) or transmitted-light color transparencies. Some of the best duplication services in Hollywood use electronic flash in this way.

Many pictures in this book were made from 5″ × 7″ color transparencies copied on 2¼″ × 2¼″ Verichrome Pan negatives. Development in D-23 was approximately 3 minutes in part "A" and 4 minutes in part "B." It is very difficult to tell a low-contrast, black-and-white copy negative from an original black-and-white negative.

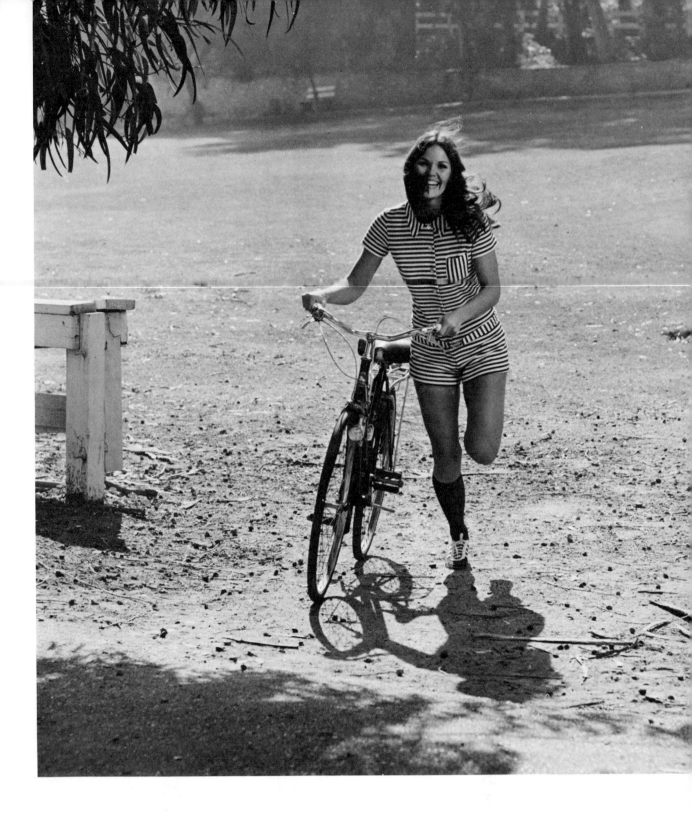

An action color setup, using a 35mm Pentax, shows model Annette Molen running with a bicycle. We used a local park for the background and positioned the model so that the sun lighted the grassy area behind her.

11

COLOR CHARACTERISTICS

The color quality of the light produced by most electronic flash units closely approximates that of sunlight. Since daylight color film is balanced to the usual mixture of sunlight and skylight, it can usually be used for speedlight photography without special filters.

There are exceptional circumstances, of course, when a filter is desirable to "warm" a scene. Certain emulsions need this warming filter because the electronic flash is likely to be of a higher color temperature than sunlight. Noonday sun is usually 6000 K while most speedlights are 7000 K. A warming filter will reduce the color temperature of the speedlight to that of daylight. Consult the instruction slip that accompanies your film for recommended warming filters.

With sync-sun, filters aren't necessary because the speedlight is used as a supplementary light source. If the shadow area being filled by the speedlight seems to be on the cold or bluish side, don't worry about it. This is typical of shadow areas.

Most of my 35mm Kodachrome 25 and 2¼" × 2¼" Ektachrome Professional Daylight and Ektacolor pictures are shot without filters. Only with the larger cut films—4" × 5", 5" × 7", and 8" × 10"—do we feel the need for filters. There are slight variations in emulsions in all color films and the manufacturer's instructions should be carefully followed.

KODACOLOR II FILM

There is much to be said for a color negative process, such as Kodacolor, because it affords tremendous latitude in exposure as well as in color temperature. Even if you overexpose an average subject two full

Model Chris Holter poses beside the setup consisting of two Norman 125 watt-second lamp heads and one Norman P125S power supply that were bounced against two 36-inch Larson Super Silver Reflectasols. The convenient one-second recycling time makes shooting with this setup a pleasure.

stops or underexpose a full stop, you will usually be able to get a good print. Moreover, you can shoot by daylight, flashbulbs, or electronic flash *without* filters. Reason: The variations in exposure and light temperature are compensated for electronically by the commercial printing machines, which automatically alter the amount of light or slip in the right filter. These mechanical brains can often do an excellent job of compensation for light-source variations and differences in exposure. But like anything else, they have certain limitations. Don't throw all caution to the winds and expect a machine to perform the impossible.

Many of my color pictures are made with the subject posed against very intense red, orange, or blue backgrounds. This can create problems when the negatives are fed into a machine for printing; mainly because the machines are designed to take an *average* color negative, and they "think" the color of the light must be off when they are confronted with large areas of intensely bright colors. Consequently, they try to change the printing light accordingly.

Note how evenly the light is balanced for these color shots of Brooke Mills, left, and Shelley Green, right. Both were made with umbrella bounce light.

The automatic machines usually print subjects with red or orange backgrounds so that the face of the subject has an overall bluish cast. If a blue background were used, the face might have an orange cast.

This can be corrected by a custom printing job—in which case two or three test prints are made before the final combination is achieved. I mention all this in the hope that you will not put your commercial lab to as much trouble as I do. To play it safe, *don't dominate the picture area* with a background too strong in any special color.

Since the machines are geared to normalities of color, they are also geared to normalities of density. If you work with a completely white background you are apt to find the subject too dark in the print. If you use a completely black background you are apt to find the subject too light in the print.

PROCESSING YOUR OWN COLOR

Although color processing can be fun and can save you some of the developing and printing costs, it does take time and work. Among the films for home processing are Ektachrome-X, GAF slide film, Kodacolor II, and Ektacolor. (Note: Kodachrome cannot be home processed.) Since each of the films that permit home processing requires a different set of chemicals, it is impractical to have enough tanks to contain *all* the different solutions required. It is also impractical to process color film at home if you shoot only 2 or 3 rolls per month. A pint of Kodak Process E-3 color developer for Ektachrome Professional Daylight film, for example, will process about 6 rolls of 35mm film or 4 rolls of 120 film. If you store exposed film long enough to accumulate enough film for a processing run, you are

taking a chance on the possibility of image deterioration. Once you mix the processing chemicals, their life span (holding qualities) are definitely limited.

Don't take this as a negative attitude towards home processing. If you accumulate a considerable amount of exposed film in a short time, home processing *can* save you money. Chances are your black-and-white film-processing tanks can be used for the job. The actual work of processing color films takes more time and more exacting temperature controls than black-and-white processing. Otherwise, it is much the same.

COLOR LIGHTING

Many of the principles used in lighting black-and-white pictures are the same for color. You still need a definite key light. You want to separate your subject from the background and should have highlights in the hair. About the only basic difference is the amount of fill-in light used.

As mentioned in Chapter 10, your black-and-white pictures need highlight and shadow areas in order to create the illusion of three-dimensional roundness. In color work, the different colors themselves provide the separation.

While you can use the same lighting setup (key light, fill light, background lights, and so on), the difference between the use of color and black-and-white film lies in the placement of the fill-in light. For color, the fill light is moved in closer so that shadows resulting from the key light are less dense.

The photographer using a single speedlight should remember to change the angle of light slightly when using color film. For black-and-white pictures, a single light can purposely be held quite high in order to create interesting shadows. In color, it is better to try for a flatter light with fewer shadows.

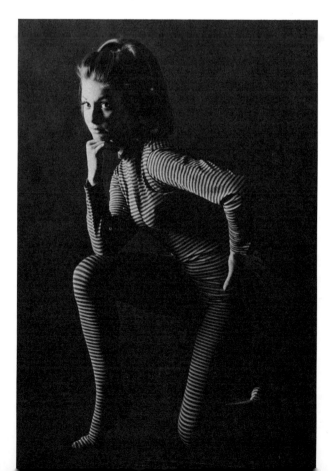

Color lighting does not always have to be flat, as in this example of Brooke Mills where a single flash is used camera left.

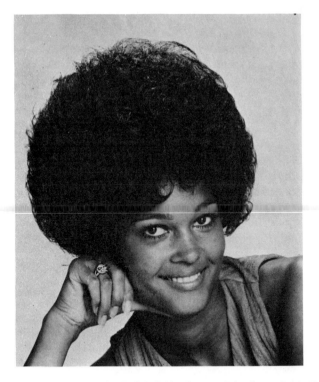 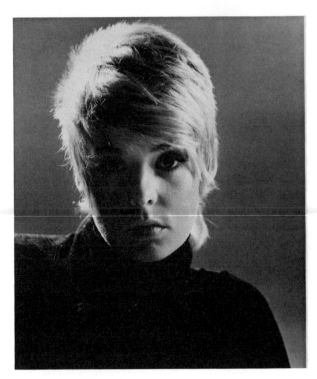

The catch lights in Sylvia Meal's eyes, left, give a clue to the number of flash heads used for flat color lighting. A dark background is both flattering and dramatic for Actress Joey Heatherton, right. The lights were positioned behind her on each side.

COLOR GELS

Interesting effects can be obtained by placing colored gelatines over some of your light sources. If you can't obtain theatrical or window-display gelatines, ordinary colored cellophane will do.

It is a good idea to mix your colored lights with straight (unaltered) light. In other words, don't cover every light head with a colored gelatine. The gelatines seem to work better for back- or edge lighting than for key or fill light.

Another interesting use for colored gelatines lies in making multiple-exposure shots. You might try red on one image, blue on another, green on a third, and leave the final image natural.

SUMMARY

1. In conclusion, think of a speedlight as the most versatile light source—potentially, at least—that you have ever used. It is economical after the initial investment. It is powerful and dependable. It consistently yields light approximating daylight quality, thus enabling you to stock only one type of color transparency film. It is of extremely short duration—ideally suited for natural-looking, squintless portraiture. It freezes action that no other light source could capture without blurring.

2. In choosing a speedlight, buy only as much power as you need. You will require less power for a 35mm camera than for a 4″ × 5″.

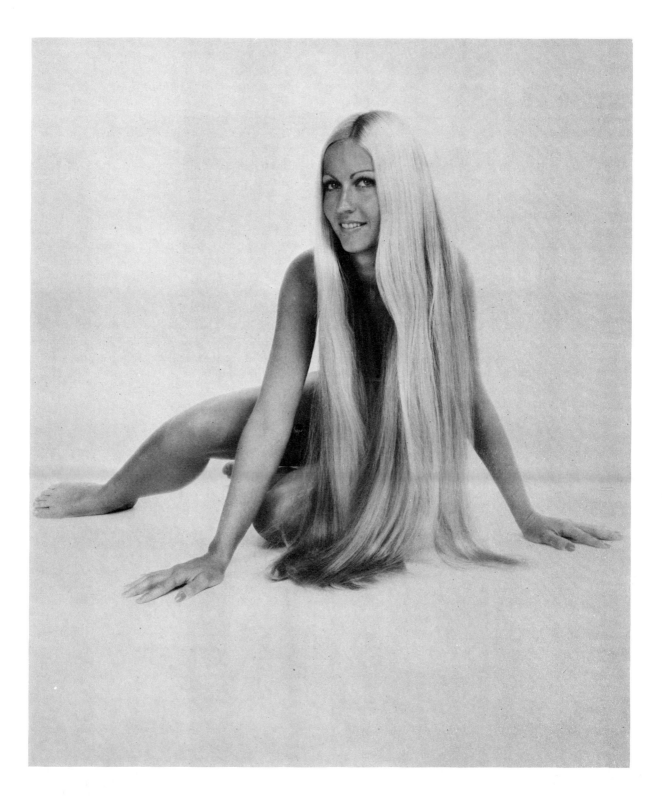

Lovely model Kathy Glade.

3. Learn the basic principles of what makes electronic flash work. Anybody can check sync with electronic flash because it is either in or out—never halfway. Flashbulbs, on the other hand, can be only partly in sync, resulting in underexposed pictures. Learn the elements of lighting first with only one light, then with a reflector or second light. Don't be in a hurry to buy a third or fourth light. Perhaps you'll never need them.

4. Bounce light from a single speedlight can take the place of many lights. It yields its own special kind of mood-building illumination, too. Be sure to give it a try.

5. Sync-sun picture taking is simple when you use these guide-number principles: (a) divide the f/stop you want to use into the proper guide number to arrive at your flash-to-subject distance; (b) divide the flash-to-subject distance you want to use into the proper guide number in order to arrive at the right f/stop.

6. Your shade pictures can have all the snap and contrast you want if you follow the suggestions made in Chapter 7.

7. Action pictures are a cinch with speedlight. You will not realize just how easy it is to stop action until you have tried it. A slow shutter speed—or even an open-flash setup—takes *every* picture at the speed of the flash duration itself.

8. Before you get into multiple flash on a large scale, look into the possibilities of adding another head to your present unit. Remember, too, that slave units powered by AC current offer an ideal way of increasing your flash sources inexpensively. All you do is plug in the slave unit and position it where you want it for edge, top, back, or fill light. When your key light is triggered, the slave follows suit instantly, without the slightest drain on your key-light power.

Good shooting!

Two backlighted pictures with strobe lighting from the front. Model Cindi Wood was photographed in different locations. Fortunately, both locations are within seconds of my studio.

12

GLOSSARY OF TERMS

A

AA Cell—The most inexpensive battery used in electronic flash units. These are the same cylindrically shaped batteries used in "penlight" flashlights.

AC Unit—A speedlight unit that operates on 115- or 120-volt house current as opposed to a unit that uses batteries.

Aperture—The lens opening that admits light to the film. The size is controlled by the diaphragm, which is marked in *f*/stop numbers.

B

Beam Candle Power—A universal measurement of light used to rate the total light output of an electronic flash unit.

Between-the-Lens Shutter—A mechanical device for controlling the length of exposure. The majority of cameras have this type of shutter located between the lens elements.

Blocking—(blocked up) Overexposure of the highlight areas, which results in a loss of detail.

Bounce—Light that illuminates a subject by being reflected from a wall, ceiling, umbrella, or other light-colored surface.

C

Capacitor—The part of a speedlight unit which stores the energy used to create the flash. Also called a condenser.

Color Correction—Use of a filter or filters to achieve a difference in color balance.

Color Temperature—The warmth or coolness of light expressed in Kelvin. A "warm" color transparency, for example, is visually stronger in reds than in blues; in a "cold" transparency, the blue tones predominate. An example of warm lighting is late afternoon sunlight.

Condenser—Another name for capacitor.

Contrast—The range of light and dark tones in a picture. A print is "flat" when it is low in contrast; "full scale" when many gradations of tone between black and white are present; "soft" when the contrast is moderate; and "hard" when there is too much contrast with a corresponding lack of detail.

D

Diaphragm—Thin metal blades that open and close to regulate the amount of light admitted through the aperture of the lens. It is usually regulated by the *f*/stop-control lever.

F

Flat Light—A type of light (usually direct front light) that provides very little contrast between highlight and shadow areas.

Fill-in Light—A secondary light positioned in such a way as to illuminate the shadows caused by the main, or key, light.

Flash Terminals—The terminals installed in a camera for connecting to the flash unit. Different types of terminals require special tips on their connecting cords. Your dealer can show you the type of cord best suited to your camera-flash combination.

Fog—A partial or overall veil in a negative that appears as a dark streak or patch. It is often caused by light accidently reaching the negative, i.e., "light fog." Sometimes caused by errors in mixing or using developing solutions, i.e., "chemical fog."

Focal-Plane Shutter—A shutter located just in front of the film. It is usually made of cloth or metal, mounted on rollers, and actuated by spring tension. Exposure is controlled by various widths of slots in the curtain, which move across the film when the shutter is released.

Film Speed—In the United States, most black-and-white film speeds are given ASA ratings. In parts of Europe, other types of ratings are employed. Color films are given Exposure Index ratings in lieu of ASA ratings. In most cases, the instruction slip that comes with a roll of film will indicate its ASA rating or Exposure Index.

Focus—The adjusting of a camera lens setting that produces a sharp image.

f/Stop—Numbers used to denote speed of a lens. In actual practice, the higher the number of the *f*/stop you select, the smaller the opening of the diaphragm will be. For example, when you set your lens at *f*/16, you are admitting ½ the light of *f*/11; at *f*/22, you are admitting ¼ the light of *f*/11.

G

Ghost Image—The secondary image that results when electronic flash is used at too slow a shutter speed in the presence of other light sources capable of recording independent images on the film.

Grain—The appearance of texture caused by the small crystals of silver halide in a photographic emulsion. As a rule, grain is considered excessive when it becomes visibly objectionable (distracting) in a print.

Guide Number—The power of a flash unit is usually rated on the basis of a Kodachrome guide number, which consists of the product of the *f*/setting with the distance between the flash and the subject. The *f*/setting is determined by dividing the guide number by the flash-to-subject distance. Example: with a guide number of 110 and a distance of 10 feet, you would arrive at a diaphragm setting of *f*/11 (110 divided by 10 equals 11). Guide numbers can also be used to determine how far the flash should be positioned from a subject in order to make use of a predetermined *f*/stop. Example: with a guide number of 110 and a predetermined stop of *f*/11, the flash-to-subject distance should be 10 feet (110 divided by 11 equals 10).

K

Key Light—The main light used to illuminate a subject. It can be sunlight, floodlight, flashbulb, spotlight, or electronic flash.

L

Lens Opening—The size of the aperture (as indicated by the *f*/stop of the diaphragm).

M

Main Light—*See* Key Light.

Modeling—The illusion of depth or third dimension given an object by controlling the position and angle of the source illumination.

M Sync—The built-in shutter synchronization in a camera intended for use with regular flashbulbs. Not suitable for use with electronic flash.

Multi-Vibrator—A multi-vibrator converts DC to pulsating DC so that low voltage can be raised to the necessary voltage required for electronic flash.

N

Nickel Cadmium—A storage battery that may be recharged an indefinite number of times. Does not require the addition of liquids, and is usually guaranteed for ten years.

R

Ready Light—The ready light (glow light) indicates that the capacitor of the speedlight has stored up enough energy to be fired but not necessarily at full power. Some units have ready lights that burn steadily when the capacitor is fully charged; others utilize a flashing system. It is good policy not to flash the unit at the first sign of light, but rather, to wait twice the time it takes for the light to appear.

Recycle—The time it takes an electronic flash unit to build up a full charge after it has been fired. The average time for most popular units is from three to ten seconds. As the batteries run down the recycling time will increase.

S

Stop—Two photographic meanings: (1) to halt, or freeze, action in a picture; (2) as a synonym for "aperture," i.e., stop 6.3, instead of *f*/6.3.

Synchronize—To time the firing of the flash with the camera shutter so that all the light passes through the lens while the shutter is open.

Sync-Sun (Synchro-Sun)—The simultaneous use of flash and sunlight in picture taking. The lens diaphragm must be set so that the film is exposed by the right amount of light from each source. The shutter and *f*/stop settings control the sunlight exposure while the *f*/stop setting controls the amount of speedlight exposure.

W

Watt-Seconds—Watt-seconds are a measurement of the amount of energy a condenser may store, but are not a measurement of the light output of a given unit. Small units range from about 30 watt-seconds to approximately 200 watt-seconds. Commercial studio units range from about 125 to 40,000 watt-seconds.

X

X Contacts—Flash contacts designed to fire a speedlight unit at the exact instant the shutter is fully opened.

X Sync—A no-delay, shutter synchronization designed especially for speedlight use.